HISTORIC TALES *of*

La Jolla

Patricia Daly-Lipe

THE
History
PRESS

Published by The History Press
Charleston, SC
www.historypress.net

Front cover, top: Gold Fish Point from Cave Street. Watercolor by Georgeanna W. Lipe.
Back cover, top: La Jolla Cove. Watercolor by Georgeanna W. Lipe.

First published 2017

Manufactured in the United States

ISBN 9781467135993

Library of Congress Control Number: 2016950691

Contents

Contents

Acknowledgements

The story of La Jolla could not be told without the assistance of experts. Special thanks to the research and work of archaeologist Dr. Therese Muranaka, Architect Professor of Environmental Design Eugene Ray and Gary Fogel, for his chapter on La Jolla's Gliderport. We are also grateful for the articles written by historical and architectural specialist Linda Marrone and by Terry Rodgers, staff writer for the *San Diego Union* newspaper. Plus thanks to Dr. Sarita Eastman for sharing memories of her mother, Dr. Anita Figueredo. Also, Susanne Pistor shared with us her research about La Jolla in the library's La Jolla History Room, where she volunteers. Plus, we cannot forget the late Barbara Dawson, who helped me write weekly articles about La Jolla for *La Jolla Village News* over a period of two and a half years.

But the biggest thanks goes to the man who assisted in all aspects of creating this book, including editing and research, my husband, Dr. Steele Lipe.

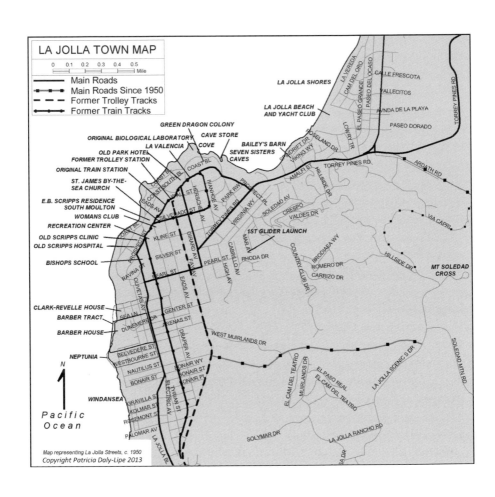

LA JOLLA TOWN MAP

0 0.1 0.2 0.3 0.4 0.5
Mile

—— Main Roads
—■—■— Main Roads Since 1950
— — — Former Trolley Tracks
—●—●— Former Train Tracks

LA JOLLA SHORES

LA JOLLA BEACH
AND YACHT CLUB

CALLE FRESCOTA
YALLECITOS
AVNDA DE LA PLAYA
PASEO DORADO

LA VEREDA
CAM DEL ORO
EL PASEO GRANDE
PASEO DEL OCASO
LWR RV TR
TORREY PINES RD

GREEN DRAGON COLONY
CAVE STORE
ORIGINAL BIOLOGICAL LABORATORY
LA VALENCIA COVE
OLD PARK HOTEL
FORMER TROLLEY STATION
ORIGINAL TRAIN STATION
ST. JAMES BY-THE-
SEA CHURCH
E.B. SCRIPPS RESIDENCE
SOUTH MOULTON
WOMANS CLUB
RECREATION CENTER
OLD SCRIPPS CLINIC
OLD SCRIPPS HOSPITAL

BISHOPS SCHOOL

BAILEY'S BARN
SEVEN SISTERS
CAVES

COAST BL
C ST
COAST BL
SOUTH BL
IVANHOE AV
HERSCHEL AV
PARK RW
PROSPECT PL
VIRGINIA WY
TORREY PINES RD
AMALFI ST
HILLSIDE DR
ROSELAND DR
ANDRIFT DR
VIKING WY
TORREY PINES RD
ARDATH RD

WALL ST
EADS AV
SILVERADO ST
DRAPER AV

KLINE ST
GIRARD AV
SILVER ST
PEARL ST

SOLEDAD AV
CRESPO
VALDES DR
1ST GLIDER LAUNCH
MAR AV
CABRILLO AV
HIGH AV
PEARL ST
RHODA DR

COUNTRY CLUB DR
BRODIAEA WY
ROMERO DR
CARRIZO DR
HILLSIDE DR

VIA CAPRI

MT SOLEDAD
CROSS

PROSPECT ST
COAST BL
RAVINA ST
OLIVETAS AV

CLARK-REVELLE HOUSE
BARBER TRACT
BARBER HOUSE

NEPTUNIA

N

Pacific
Ocean

WINDANSEA

SEA LN
DUNEMERE DR
GENTER ST
ARENAS ST

EADS AV

DRAPER AV
WEST MUIRLANDS DR

BELVEDERE ST
WESTBOURNE ST
NAUTILUS ST
BONAIR ST

GRAVILLA ST
KOLMAR ST
ROSEMONT ST

PALOMAR AV

BONAIR WY
BONAIR ST
BONAIR PL

TYRIAN ST
ELECTRIC AV

LA JOLLA BL

SOLYMAR DR

EL CAM DEL TEATRO
MUIRLANDS DR

EL PASO REAL
EL CAM DEL TEATRO

LA JOLLA RANCHO RD

LA JOLLA SCENIC S DR

SOLEDAD MTN RD

Map representing La Jolla Streets, c. 1950
Copyright Patricia Daly-Lipe 2013

1
La Jolla in a Seashell

*Without social history, economic history is barren
and political history is unintelligible.*

*Truth is the criterion of historical study;
but its impelling motive is poetic.*

—*G.M. Travelyan,* English Social History *1 (New York, 1949): xxi–xiii*

"Location, location, location." This is the mantra for real estate. But it is precisely "location" that helped define La Jolla. *Historic Tales of La Jolla* tells the story of that place: its name, even its initial creation by natural forces, followed by the people who found and fell in love with it. This is history from a personal perspective. What did La Jolla do for the people who came, and what did these people do for La Jolla and, in many cases, for the rest of the world?

On the 350-foot sandstone bluffs between La Jolla and Del Mar are sediments and ancient marine deposits over seventy million years old. The village of La Jolla, however, is built on a terrace that was cut out not so long ago. Terraces are formed when there is an uplift from deep within the earth. Much of La Jolla's early history is a mystery. So, in this overview of La Jolla's past, let us jump ahead to the year 1850 when the lands of La Jolla, as part of the Pueblo land grant, were incorporated as part of the City

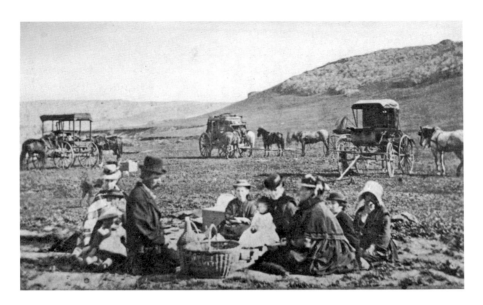

Enjoying a picnic at what will eventually be Scripps Park, 1870s. Note the barren landscape of undeveloped La Jolla. *Copyright La Jolla Historical Society.*

of San Diego. But there were no permanent settlers in this section of town until 1869, when two brothers, Daniel and Samuel Sizer, each bought an eighty-acre plot. The City of San Diego sold these plots for $1.25 per acre. Located between present-day Fay Street and La Jolla Boulevard, they would be worth nearly $2 million per acre today. However, most consider 1887 the year of La Jolla's actual founding. This is when lots were auctioned in the first subdivision, called La Jolla Park.

In 1887, Frank Botsford, a thirty-five-year-old New York City stockbroker of substantial means, came to La Jolla with his wife. Fully aware of the land boom in San Diego, he had traveled up the coast and discovered what was to become La Jolla. He began surveying the virgin territory located above the Cove and selected a lot at the southwest corner of what is now Prospect and Ivanhoe to build his home. On January 26, 1887, he wrote in his diary, "Bought La Jolla!"

Following his lead, early settlers built their shingled houses on the sloping hillside above the Cove. What a view these early residents had! The coastline stretched to the north totally barren, unpopulated and unpolluted. They could smell the fresh sea air, hear the barking seals and watch the pelicans, cormorants and sea gulls as they floated overhead on their way to and from the caves below. Sagebrush covered the land in all directions. The eight-hundred-foot-high mountain named Soledad guarded this private

little paradise. Every spring, Mount Soledad was covered with wildflowers: shooting stars, Indian paintbrush and California poppies.

In 1893, the railroad came to La Jolla with its steam and gas trains. La Jolla was launched! Within four years, there were one hundred homes, plus several stores, in the colony.

Mr. George H. Chase owned the first general store, which was located across the street from the Cove. Next door was the post office, which had opened in 1894. In 1899, Mr. Chase purchased the Heald Store, which in the early days had housed the first La Jolla school on the second floor. (In those days, there were only eighty students, and there was no fourth grade.) It also had a livery stable on the ground level. Located on the corner of Herschel and Wall Streets, he had it moved onto his property on the northeast corner of Girard and Prospect. Picking up and moving houses became a common practice in the early years of La Jolla. The building the school had occupied became the Chase and Ludington store in its new location, and a new school was built for the students. But for high school, students had to attend the school in San Diego.

In 1894, another transaction occurred. "One hundred and sixty-five dollars. And it's a bargain! Fifty feet along the street, some 200 feet deep, and it widens like a fan so that it is 150 feet along the seashore. It's a bargain, I tell you!" said the doctor. Anna Held made the deal, giving the doctor a fifty-dollar deposit on the land, sight unseen. Three days later, Mr. and Mrs. Ulysses S. Grant Jr. drove their nanny to see her "estate" by the sea. The view was breathtaking. From the level on which they stood, the land fell sharply to the edge of the ocean. Across the narrow inlet bay nearby rose a kindred height with a rough, rocky point jutting out to sea. Then, just beyond, began a yellow sweep of shore, a rim of golden cliffs, curving far to the north clasping the ocean's cobalt blue like a jewel.

In San Diego, Anna had met a young lad named Irving Gill, "whose love for house designing was coupled with ability." His first commission was to make plans for a house to be built around Anna's beloved fireplace, the sole object she had erected on her property. For this, he received fifteen dollars, 5 percent of the total cost. Thus was the beginning of what would be the Green Dragon Colony, for years the best-known place in La Jolla, a mecca for artists, authors, poets, musicians, actors, singers—in sum, creative people from Europe who were invited by Anna to visit her in La Jolla throughout the years. With each visit, a new cottage, each in an original style, was built to accommodate the guests.

Across and behind the Green Dragon Colony was the famous La Jolla Cave and Curio shop. Originally a cluster of board-and-batten shacks and

Sunny Jim Cave after construction of access tunnel. *New York Public Library.*

cabins, a building developed as a means for its owner, Professor Gustav Schulz, artist, photographer, professor and engineer, to control access to the entrance of a manmade tunnel leading down to Sunny Jim Cave, named because of the outline of the cave against the backdrop of the ocean. Sunny Jim is but one of what are known as the "seven sister caves" at the base of the cliffs. Legend has it that pirates found the caves by locating a strange and unique grove of trees, the Torrey pines. Just beyond these trees is a long beach, the future La Jolla Shores, and then the cliffs and the caves. Perhaps they used the caves to hide loot. It is said that contraband whiskey was also hidden in Sunny Jim Cave during Prohibition.

In 1902, Professor Schulz bought the land above the cave from Miss Anna Held. One of the reasons he had chosen to live in San Diego was the existence of a colony of fellow German Americans who had gravitated to the oceanfront village of La Jolla. The nucleus of this German American enclave was focused in and around the Green Dragon Colony.

Houses and stores continued to spring up at random along the streets of Prospect, Girard, Wall, Herschel, Ivanhoe and Coast. Another gentleman who helped found La Jolla, Mr. Walter Lieber, stopped for a brief visit and then decided to stay. Born in Philadelphia in 1860, Mr. Lieber had been to Mexico doing mining exploration. He became ill and, in 1904, took the train to this coastal resort, La Jolla. He said the one hundred or

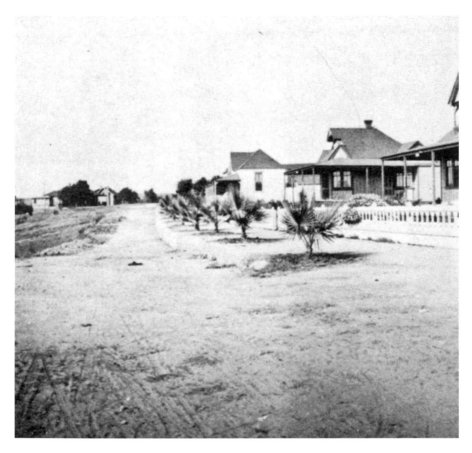

Pictured here are some of the early Washingtonian palm trees planted by Mr. Lieber along Prospect in front of the Chase & Ludington Store. *Copyright San Diego Historical Society.*

so cottages in La Jolla were "inhabited by old maids and widows, with men very scarce." What incentive for a bachelor! He rented a cottage, paying all of nine dollars a month. "Scripps Park was then a place of tents entrenched in piles of manure, tins, bottles, and trash. La Jolla had cow paths in lieu of streets, deep to the ankle in summer with dust, in winter as deep in mud." He continues, "[W]ater only fed into the village by a two-inch pipe, and none in that pipe during the day, so we had to stay up at nights to get enough water for the next day's needs." To make life even more difficult, "there were [only] three bath tubs in the village, fed by cold water."

In 1907, now married to Jennie Beaudine, Lieber purchased a lot at the extreme edge of the original La Jolla Park Subdivision. Over the years, and well into the 1920s, Mr. Lieber built several cottage colonies for vacationers.

Clearly, this describes one of La Jolla's very first real estate moguls. Mr. Lieber was also a community philanthropist. On an early postcard, he wrote, "I planted all of these trees many years ago," referring to the Washington palm trees that line Coast Boulevard and other main streets today.

In those early days, all the people of La Jolla knew one another. Doors were never locked. Notices were put on the post office wall inviting everyone to join the party or dance on a Saturday night at the Pavilion. During this time, the colony was quite a cultural center. Clubs were organized. The library was established. All types of civic events were celebrated. Many famous people came to enjoy a holiday or a short-term visit in this lovely little resort-like town. The pioneer La Jollans were not only active socially and culturally, but they were also a loving and caring people. If any family was hungry, needed clothing or required medical attention, someone would arrange anonymously that they get what was needed.

After the turn of the twentieth century, in 1902, according to the *San Diego Union*, "August has come in and found the resort with hardly a room to spare while extra cars are in service every day for transient sightseers." The "extra cars" would be referring to the San Diego, Pacific Beach and La Jolla Railway. The article continues: "The August warmth has rendered the evenings positively balmy, and the most phlegmatic resident seeks the peace and dreams in the glow of the sunset coals, wondering at the vague symbolism of sky and sea and night." Wow, they don't write like that anymore!

Those trains made trips between La Jolla and the City of San Diego, but they were neither regular nor reliable. This was especially true when trains converted from steam to gasoline. Many times, it was the steam engine that had to get the gasoline cars out of trouble. After too many complaints and problems, when the train franchise ran out, it was not renewed. The era of train transportation in La Jolla ended in 1919.

Later, when our country became involved in World War I, soldiers were stationed at Camp Kearny just east of La Jolla on the mesa. This attracted more people to La Jolla. In turn, a few years later, land developers subdivided more of the area into La Jolla Shores, La Jolla Hermosa and the Muirlands.

Another addition to the influx of inhabitants to La Jolla was the opening of the Panama Canal in 1914. Also, by this time, a direct railroad linked Los Angeles to Salt Lake City and the East. And as far back as 1903, the first cross-country automobile trip had taken place.

"La Jolla is a bit of sea coast of many moods and manners, sometimes sparkling, crisp, buoyant; again despondent, troubled, morose; at intervals, tumultuous, defiant, angry but the dominant mood is soothing, restful, and comforting" mused the *San Diego Union* on January 1, 1923.

In 1924, a little booklet came out titled *The Story of La Jolla by the Sea*. It is a telling commentary of La Jolla in that era. "The feat of La Jolla in producing during [1923], amid the partial paralysis of a presidential election year, a thousand dollars' worth of building permits for each of its four thousand inhabitants, or a total of four million dollars' worth of construction in all, may be unprecedented. At any rate, it dwarfs the statistics of the rest of Southern California, which may be said to be the home of statistics." At the time, Los Angeles produced but one-tenth of building permits compared to La Jolla. Actually, La Jolla even outgrew San Diego. According to the pamphlet, "[T]he purpose of these pages is no eulogy of mere growth, because La Jolla does not desire to grow so much in size as in beauty, and to this end has restricted itself to high-class residential and business purposes." After a lovely description of La Jolla, with its serene sea and blue sky and brown mountain slopes, the little pamphlet states, "As someone has said, La Jolla is New England dead and gone to heaven."

By 1924, many celebrities had come to live in La Jolla—famous authors, scientists, painters, musicians, sculptors, world travelers, lecturers—in sum, a large number of names in "Who's Who." Despite this high social sophistication in La Jolla, "wealth is never obtrusive and moderate means never a disadvantage." *Simplicity* and *serenity* were the two words that best defined La Jolla in the 1920s.

In 1925, streetcar tracks were laid, improving transportation between La Jolla and San Diego. People could now live in La Jolla and work in San Diego. Home construction began in the new subdivisions. In these new areas, as well as in the older ones, streets and sidewalks were being paved. Walking around La Jolla today, you can still see signatures and dates carved in the cement designating these original sidewalks. (Homeowners paid for the portion laid in front of their homes.)

The first telephone in La Jolla was installed in 1899. By the 1920s, the main telephone numbers were easy to remember. Beginning with the number 21, the following two numbers were 31, 41, 51, up to 91. 2121 was the hospital number. 2131 was the gas and electric company. The Bishop's School and the Casa de Mañana followed in sequence. Dr. Parker's number was 2161. When Dr. Lipe (the author's father-in-law) took over the practice, the number remained the same but with a new prefix, Glencourt. Almost

Sidewalks were the financial responsibility of the property owner and laid by many contractors who left their marks for posterity. *Personal collection.*

all of these numbers remained the same right up through and often beyond 1955. Of course, in the early days, you spoke with an operator who then made the connection. The operators must have had stories to tell! It is the little things, like telephone numbers, that remind us how small La Jolla once was and how intimate.

By 1920, the population of La Jolla had reached approximately 1,850, double the population of 1910. According to a contemporary magazine article, "They all came back to La Jolla, Sunset Land. They find that 'peace, perfect peace,' which is seldom found in this hurrying, troubled world." These words, written in the early '20s, described visitors to La Jolla. Imagine what the writer would think about La Jolla today. Traffic, noise, crowds. However, if one takes a walk along the coast at sunset, the peace is still there.

Many of the early houses had floral names like Honeysuckle Lodge (on Fay Avenue) and Wisteria. Some names were more humorous like Red Rest (the bungalow by the Cove that was, of course, painted red); Neptune, aka Red Roost; and Aksarben, which is Nebraska spelled backward.

More people came and fell in love with this mecca by the sea, and La Jolla continued to expand and change. Streets were renamed to reflect an emphasis on famous people in the fields of science, literature and American history. Grand became Girard; Connecticut became Silverado.

The real estate boom of the '20s stopped suddenly with the crash of 1929. The Depression hit La Jolla as it did the rest of the country. According to

Red Rest before it was allowed to decay. *Library of Congress.*

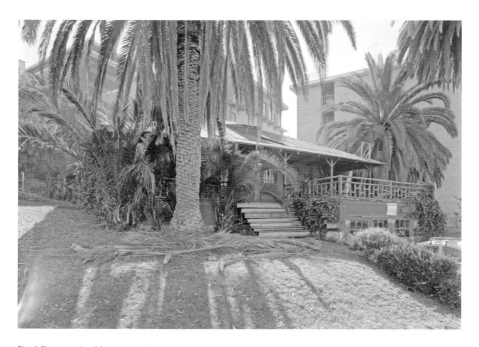

Red Roost, aka Neptune. *Library of Congress.*

one magazine, "Readers began to see features dealing with the nature of economic depression and proposals for ways to bring about the return of the good times of the twenties….While many retained their vigor and optimism, concern was deepening and the specter of the growing depression was rising over a bewildered people. The prosperity of the twenties had gone and no one really knew why." It was ten years before La Jolla showed signs of recovery.

After World War II, the population in La Jolla soared. In 1960, the University of California–San Diego began building on the grounds of the old Camp Matthews and Camp Callan (troop sites from World War II). With students and faculty and families simply seeking a new home in a perfect climate, by 1970, the inhabitants numbered 25,290. Twenty years later, it exceeded 40,400. Real estate prices continued to soar as well.

Bill Kellogg (whose family has owned the La Jolla Beach and Tennis Club for five generations) said in 2005, "When UCSD came in, it turned La Jolla from a sleepy little village into a bustling town. Now it's a real city, although it's got a small town character." While the past was calm and quiet, the future will hopefully retain the village feeling.

May we never forget that La Jolla that was the "Sunset Land" of bright solace and simple, anonymous living by the brown mountain slopes and the serene blue sea.

2
A Very Early History of La Jolla

By Therese Muranaka, PhD, RPA

As the coast off La Jolla became free of ice about 14,000 BC, Native American peoples began migrating south along California coastlines that one would not recognize today. Until the ice melted more fully in the later Holocene Epoch, the coastline they knew at La Jolla was much farther out than its current location. As archaeologists and those who study climate change discovered, these people settled coastal California even before the last glacial maximum (toward the end of the Pleistocene Epoch in geologic history). By 13,000 to 9000 BC, California had become their home. By 10,000 BC, for example, humans had settled Santa Rosa Island on the Channel Islands, and by 9500 (years calibrated BC) people had visited San Miguel Island. Much closer to home, they were fishing and hunting at Agua Hedionda Lagoon (south of Oceanside) by 9210 BC.

These Paleo-Coastal peoples must have had seaworthy boats and very sophisticated sea-based cultures. They hunted for otter, seal, walrus and sea birds and for "rocky intertidal taxa" like black abalones, turban snails and California mussels. They fished sheephead, rockfish, cabezon and surfperch found near the shore and in the kelp beds. Flaked stone tools, shell trade beads (*Olivella biplicata*), sea grass woven into cords and maritime tools like fish gorges (these being the oldest fishhooks in the Americas known to date) were found on these islands.

By 8000 BC, when the Holocene Epoch developed, climate stabilized for a longer period, and new adaptations were made for survival. Named in times past the La Jolla Culture of the Archaic Period, Indian settlements

in La Jolla proper existed by 7500 BC in the hills above today's town, as well as offshore. Sites with thousands of shells, called "shell middens," have been found with split cobble tools and contain evidence of grinding stones (*metates*) and hand stones (*manos*) for processing plant materials like Torrey pine nuts. Populations grew, but not much is known about their social customs, religion or ceremonial life. One can be sure, however, of their appreciation of the stars, the tides and the storm patterns that dictated their lives.

The climate, never stable for long, changed yet again, and the deep, highly productive bays and inlets the La Jollans took so much sustenance from began to silt in about 3000 BC, becoming shallow and creating the sandy beaches more familiar today. The climate by the Late Holocene (1000 BC) was varied, cooling more, and even registering a neoglacial period about 500 BC. Traces of these changes are found in the stone tools, weapons (the bow and arrow appears about AD 500), house types, jewelry and the plants and animals they hunted. These were the people the Spanish met at the time of European contact (from the arrival of Cabrillo in 1542 until the Portola Expedition of 1769). These were Yuman language speakers related to similar peoples along the lower Colorado River. Archaeologists see traces of these people in San Diego and Imperial Counties, as well as the Tijuana to Ensenada area since AD 1300 or so. Their sites on both sides of the border are scattered, often impacted by modern development and not always easy to date, but they are well into the period archaeologists named for convenience the "Late Prehistoric." Since most archaeologists are not of tribal descent, they can only summarize what is known about Indian people at this time. The descendants of these people themselves, now known as the Kumeyaay or Ipai/Tipai, have more information than an outsider could know. Although archaeologists see traces of these unique people coming to San Diego beginning about AD 1000 to 1300, the Kumeyaay people will tell you they have always been here, from the very beginning to the end of time.

Daily lives in AD 1000 consisted primarily of a seasonal round of hunting small game and gathering wild foods. The Spanish noted that, yearly, they traveled from the Ensenada area to Mission Beach, for example, and then moved up to the Cuyamaca Mountains for the fall acorn harvest.

There they met with desert Indians, who arrived for marriages and ceremonial events. Some archaeologists even think they were beginning to deliberately grow plant foods and set controlled burns, as were their relatives down on the Colorado River and in Arizona and northern Mexico.

The Kumeyaay were probably organized into small bands of related family members who harvested buckwheat, toyon, lemonadeberry, sumac

A basketful of acorns, a staple food of the Late Pleistocene Epoch. *Copyright San Diego Archaeological Center.*

and black sage and hunted mule deer, rabbits, ground squirrels, many species of birds, reptiles and other animals. They probably had boats of reeds, hunting otter, seals and perhaps whales, as well as gathering shellfish such as abalone, clams and freshwater mollusks. It is noted they relied more on near-shore and less diverse species than their predecessors, species such as the shell *Donax gouldii* and grasses such as *Hordeum* and lotus. They made jewelry of perforated and ground seashells and traded it as far away as the Gulf of California in exchange for coral.

Scientists have also found pottery sherds, made of local, dark-brown clays mixed with sand and chaff as "temper" so the pots would not crack in the fire's heat. This pottery is called "Southern California Brownware" or "Tizon Brownware" (*tizon* being the Spanish word for "fired," or "hard-fired"). Rarely did they decorate pottery, other than sharp lines in chevrons or other geometric patterns in the wet clay. They did sometimes prefer dots, jagged lines and circles with red or yellow paint, which was made from limonite, or hematite (iron oxide) pigments. Sometimes archaeologists find paint palettes on flat stones where they ground paints for pottery or perhaps for face or body painting. They made pottery from coils of clay, the same "snakes" of clay demonstrated to children in schools today, and used a

paddle with an anvil on the inside of the pot to smooth the coils. Most likely, they fired them in a campfire of brush, and the variation in the heat from the logs made beautiful patterns ("fire clouds") of black, gray and rust on the brown clay surface.

Kumeyaay (Ipai/Tipai) women were making the pottery at the time of the Spanish arrival. They mended pots if they were broken and reground clay shards to use the clay again. There are beautiful pieces known to have the individual fingerprints of a prehistoric potter pressed inside a vessel. The prints would not have been visible when the vessel was used, but they are once it is broken and discarded, and the inside becomes visible for all to see, a personal touch from long ago. The piece would be blackened outside from sitting directly on an open campfire during cooking. They also made ceramic smoking pipes and whistles and rattles, some of which were probably of ceremonial nature. Special pieces, such as the ceramic rattles, had human features with coffee bean eyes, a decorative detail that linked their work to similar ceramics relatives were making down along the Colorado River.

Metate and mano grinding stones were used to process plant fibers, roots and nuts that were too hard to eat or acorns, which had too much tannin, and therefore needed to be broken and soaked before consumption. Sometimes archaeologists find polished surfaces on bedrock so slick from the silica of plant fibers that it is obvious early people were beating something against the rock to make it more useful. Their arrow points and stone tools were well designed for function, but the selection of material, color and the shaping of special flourishes make it seem as if they took personal interest and pride in their production. They quarried stone that was easy to work from places like Otay Mesa and sometimes heat-treated it to make it flake more easily. Stones from far away (such as obsidian from the eastern deserts or as far away as the Coso Range) can be thin-sectioned and compared to modern sources of the same material. Aerodynamically balanced, the points were hafted with animal sinew and pitch or other resin, feathered, shot and perhaps broken or lost for an archaeologist to find a thousand years later. Sometimes protein residue can still be found on these stone tools, and a scientist can tell if it was rabbit, deer or another type of animal blood at the edges.

Legends written down by Spanish explorers and priests or just neighboring ranchers, interested parties or even anthropologists tell of a beautiful, mystic religious life, observant of solstice, life cycles and animal behavior. Spirit guides made an individual life special and created an

interface between the human and a rich supernatural world. Relationships with other Indian peoples were carefully regulated and passed on by elders. No different in that regard from any other people living today, they wished for the survival of the group, freedom from illness and want and a successful life for their children. On the other hand, as an archaeologist can tell you, they would have had no fear of flying in small planes, election returns or stock market futures.

Presently, San Diego County has more federally recognized tribes than any other county in the U.S. or its territories. The Kumeyaay are still very much here today and would resent us diminishing their lives in any way. Although having experienced invasions of foreign peoples like the Luisenos/Juanenos (Acjachemen) and Cahuilla from the northeast prior to the arrival of the Spanish, the trauma of the Spanish Era (1542–1821) was unprecedented. Cortés himself tried twice to settle Baja California in the 1530s, although both attempts failed. Spanish settlers introduced strains of smallpox and other European diseases, which Indian people unknowingly carried from village to village as they traveled up the Baja California coast, long before Portola and Serra came permanently to San Diego in 1769. During the Mexican Era (1821–46), long-held traditional villages and *rancherias* associated with the missions like San Diego de Alcala and Santa Ysabel *asistencia* (or auxiliary mission) were taken into private hands with the secularization of the mission system. The results of anti-Indian legislation are well documented in works such as Helen Hunt Jackson's *Ramona*, a novel worth reading again.

It is with great respect for these people, their ancestors and their histories that this article is submitted. It is not a "prehistory" (a story of what happened before anyone from Europe wrote anything down) because they have always had their own histories, stories, songs, rock art and ways of communicating. It is also with the greatest respect for them and for their ancestors, whose remains still lie right around La Jolla, that this author asks you to not disturb their histories, the places where so much of their memory resides.

BIOGRAPHY

Therese Adams Muranaka, PhD, RPA, is a second-generation San Diego County archaeologist. She attended anthropology departments at San

Diego State University and the University of Arizona. After studying the historic Russian colony in Baja California's Guadalupe Valley for many years, she retired in 2014 as an associate state archaeologist working for California State Parks at San Diego Coast District, a region including Border Field, Silver Strand, Old Town San Diego, Torrey Pines and San Pasqual State Parks and Reserve.

Red Rest and Red Roost Bungalows

Representatives of the Most Important Architectural Situation in La Jolla

At the turn of the twentieth century, La Jolla was a small area "of enchanting seaside topography as barren as a bone." The last remnants of this time are the Brockton Villa, built in 1894 and preserved as a wonderful restaurant, and the two cottages called the Red Rest, built by Mr. George Julian Leavy, and the Red Roost, also known as Neptune, built by Eugene Fishburn in 1895. Designated as historical sites in 1975, these bungalows are "monuments of American Architecture" (according to Professor Eugene Ray, who helped obtain their historical designation). By 1910, these bungalows were the major American residential type of architecture and represented "folk building," a style that grew in response to actual need. To further describe folk building, Frank Lloyd Wright wrote, "There should be a return to nature and to the study of innate principles by learning the spiritual lessons that the East has to teach the West. Folk building growing in response to actual needs, fitted into the environment by people who knew no better than to fit them with native feeling, buildings that grew as folk-lore and folk-song grew, are today for us better worth study than all highly self-conscious academic attempts at the beautiful throughout all Europe."

Known in Europe as California bungalows, this residential type of architecture, in particular the Red Roost and Red Rest, although they may be "very humble structures on the surface…represent the earliest most vital La Jolla spirit." Imagine owning a home by the sea for $200 to $300.

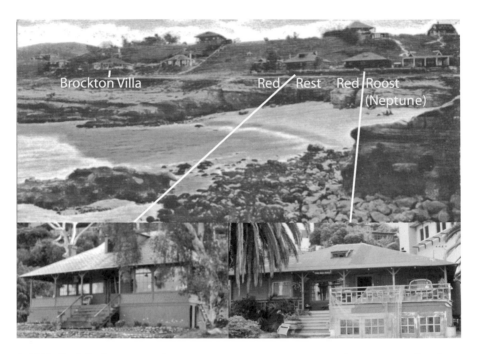

A 1900s La Jolla Cove with references to three remaining cottages. *From left to right*: Brockton Villa, Red Rest and Red Roost. *Copyright San Diego Historical Society.*

In 1988, when Professor Ray was Architect Professor of Environmental Design at the School of Art & Design of San Diego State University, he wrote a thesis regarding the "historical importance of the Red Rest and the Red Roost Bungalows and the necessity for retention at the Cove Beach site in La Jolla, California." Included in this report are letters from Vincent Scully, Yale University; Jeffrey Cook, professor of architecture at Arizona State University; Professor Bernard Lemann of Tulane University; Bernard M. Boyle, visiting professor at UC Berkeley; David Gebhard, director of the Art Galleries UC, Santa Barbara; and Robert W. Heck, acting head, Department of Architecture, Louisiana State University. All these letters were written between 1974 and 1976. And all agree. "The two bungalows on the Cove Beach site in La Jolla are monuments of American Architecture." The consensus is that we cannot afford to lose buildings that constitute "our fundamental American heritage." According to Professor Cook, "The fortune of La Jolla in having not one, but [three] historic bungalows of verifiable importance provides both an opportunity for civic pride and a responsibility to maintain and enhance such patrimony....The particulars of their setting on the Beach at La Jolla only underline their appropriate recognition as major landmarks."

Reading Professor Ray's thesis regarding the historical significance of the Red Rest and Red Roost certainly vindicates their historic status and underlines the need, actually, the necessity to preserve the two red bungalows both for La Jolla and for those interested in the history of housing. These two La Jolla bungalows have the perfect setting with the balmy air of the Pacific. Ray writes, "La Jolla has an Arcadian spirit. It is a place where the sun, the sea and the land have worked together in a magical way to produce a paradisal situation….The spirit of the two bungalows in their relation to the Cove are our earliest metaphor of this and indeed the standard bearers of the greatest American residential dream of this [the twenty-first] century."

The bungalow (from a word indicating Bengali, *bangla*), first developed in India, is a usually one-storied edifice with low, sweeping lines and a wide veranda. Professor Ray expounded, "The crowning factor that gives overwhelming value to the Red Rest and Red Roost Bungalows is their orientation to the Cove beach and the Pacific Ocean. It was in fact this great sea that mothered the type [of architecture] from its origins in the Far East. It is no exaggeration to state, after examining all of the evidence, that these two bungalows, on their site, represent the most important architectural situation in La Jolla, certainly as they relate to the history of domestic architecture in this country." This is a strong statement in terms of La Jolla possessing some excellent examples of the architecture. "The Red Rest and Red Roost," Professor Ray writes, "were progenitive types that had enormous influence on the direction of the large body of domestic American architecture and influenced quite a few master designers. The original examples related to their sites as a plant does, physically responding to the exigencies of the situation, absolutely honest and true."

The Greene brothers from Pasadena were considered the West Coast leaders for assimilating this type into heroic architecture. Harold Kirker describes this assimilation as "the first indigenous domestic architecture in California." Professor Ray said he would qualify this by calling it the first Pacific Ocean–oriented domestic architecture in modern California. The Gamble House in Pasadena was designed by the Greene brothers. It is perhaps the most famous historical shrine to the assimilated California bungalow. It should also be noted that it is preserved as a registered historical monument. Experts, such as Clay Lancaster, author of *The Japanese Influence in America*, have stated that the Greene brothers invented frameless wall (tongue and groove, diaphragm skin) construction. The fact is, however, that the Red Rest and Red Roost were built with frameless wall construction before the Greene brothers started building! This is yet another important

factor in the development of the simplified modern house and certainly should increase the historical value of the two red bungalows.

Professor Ray calls the La Jolla bungalows "the proto-typical source representation of the whole thrust of California's contribution to modern domestic architecture in the United States." He explains,

> *The key to this understanding is to be found in the verandah of the bungalows, a major metaphor of the inside-outside synthesis that exemplified the Southern California syndrome of out-of-doors living. From the Far East via the islands of the Pacific the verandahed beach house vernacular spread to the California coast as a result of colonial activities by the British, Spanish, French, Dutch, and Americans in the Pacific basin. The type was and is an excellent solution to housing in a warm, humid situation. The verandah is, in effect, an outdoor living and many times dining and sleeping room.*

It should be noted also that the word "verandah" is from the Hindustani word *baranda*, which means porch, and can be traced back in India to at least the first century AD.

The professor points out that one of the extraordinary features of the bungalow is its relaxed and informal character, which in the Gay Nineties (1890s) "was metaphorical of an optimistic spirit parallel to new inventiveness (such as the electric light bulb and lighter than air vehicles, progenitor to the airplane)." He explains, "It was natural that California would be nutrient for the new spirit and the California bungalow proliferated as its residential vehicle. The fact that the Red Rest was painted such a brilliant color represented its association with a relaxed sea-side spirit and exuberance. La Jolla was, from the early days, a jewel of the sea. The Cove was the major outdoor focal point where relaxation and communion with nature via hydro-solar therapy was a paramount relief from the daily pressures of living." (The train from San Diego, installed in 1893, increased this focalization.) "Indeed," he marvels, "in my travels across the world, I have yet to find a beach so magnetic. A natural sauna in winter with a sweeping vista—it is just about perfect."

The bungalows are "symbiotically tied with their site at the Cove and are a metaphor of the new spirited architecture that Louis Sullivan (Frank Lloyd Wright's '*Lieber Miester*') who, in 1890, with Wright, travelled all the way to California to see. It was this syndrome that fostered so much of what we know as modern architecture in California today, an architecture that

looked outward, to the sea, rather than inward" (as did the central fire place eastern seaboard influenced architecture, or even the central patio–oriented adobe Spanish Colonial houses of early California).

Interestingly, in San Diego, there are, for the weather forecaster, four climate zones. Just ten miles inland means a complete climatic change. So, in this warm, inland area, an adobe house is much more at home. Transversely, the bungalow fits perfectly at the seaside. In its early history, La Jolla was a tent town. Early photographs testify to this holiday, seaside spirit. Later, the spirit was continued in its development as La Jolla became a center for the arts. Think of Anna Held and the Green Dragon Colony (next chapter). The bright-red bungalows by the Cove were flowers of this spirit.

Just after the turn of the twentieth century, the professional journal *California, Architect and Engineer* noted the bungalow, "as it flourishes in the balmy air of the pacific coast is just now our especial pride." (One photo taken at the Cove catches an early Wright airplane gliding above with the bungalows in the background. It is not accidental that the first international air show took place in Southern California in this period and that Craftsman magazine was promoting the California bungalow as "a house for economical, healthful living.")

By 1910, the bungalow had developed into the major American residential type. Innovation, invention and healthful living have been the major thrust of California domestic architecture ever since. Louis Mumford, the famous historian, described this pattern:

> [O]ne important influence was that of tropical architecture. Robert Louis Stevenson's house in Samoa was widely reproduced in photographs in the heyday of his popularity; a house with wide window spaces and porches, adapted to the climate; and from India about the same time came the similar concept of the bungalow, with all the rooms on one floor, that swept the United States in the first decade of this century…. [T]he new bungalows popularized by the Craftsman magazine introduced many substantial innovations in housekeeping not only rationalized kitchens but the very idea of giving a house the convenience of an apartment by confining it to one floor.

The Red Rest and Red Roost are two of only three remaining examples of this very significant type of house on the La Jolla coast and possibly all of Southern California. From his experiences in New Orleans, Professor Ray says, "I know very well the importance of the preservation of architectural

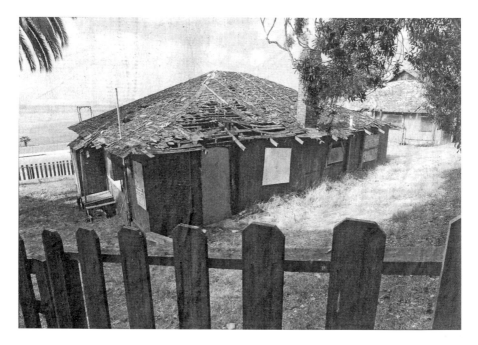

A deteriorating Red Roost. *Personal collection.*

heritage. Although they may be very humble structures on the surface, the two red bungalows represent the earliest most vital La Jolla spirit." And here is a particular passage to be noted: "A community that does not preserve its heritage is a community that will succumb to the basest facets of the human character." Will La Jolla allow this?

Over the years, the fabric of the La Jolla community has deteriorated badly with a proliferation of condominiums and mega-mansions. What good is a community filled with "large storage containers for humans"? As the professor wrote, "There must be sensitivity, humanism, and poetry in our environments or, indeed, we shall not survive." Nature is calling: the sea, the surf, the moist air, the sand, the sea life, the sunsets.

4

Anna Held and the Green Dragon Colony

*A*nna Held was born on November 3, 1849, in Berlin, Germany. The fifth out of a total of ten children, Anna loved music. As a piano student, she studied under the tutelage of Theodor Kullak (1818–1882), one of the greatest teachers of the nineteenth century. She also studied Dr. Froebel's theory of educating a child as early as age three. Because of this training, when she came to the United States from Germany, she was encouraged to start a kindergarten in New York City. Opening in the 1870s, it was the first of its kind in the United States. However, despite her success with schooling the young, she preferred living with a family. So when the Ulysses S. Grant Jr. family decided to move for health reasons, they asked Anna to join them and be the nanny for their children, three girls and one boy. The year was 1892. The family, with now-governess Anna, traveled across the country to San Diego. It was there Mr. Grant's physician thought his patient's health would improve. For two years, Miss Held took care of the Grant children. Often they would travel up the coast to a lovely place with a funny name: La Jolla. Anna loved it there, and when she was offered the opportunity to purchase land there, she was thrilled. This would be her first ownership of property. The area was above the famous La Jolla Cove with a view across the Pacific, "a magnificent sweep of yellow shore," a rim of golden cliffs curving northward with the jagged silhouettes of Torrey pines as their crown. Below, the ocean was cobalt blue, and the continuous pounding of the surf was hypnotic. Anna was transfixed, staring out to sea, smelling the salt air,

listening to the surf. This piece of paradise she bought for the vast sum of $165. The year was 1894.

The first structure built on this land was a fireplace. Anna invited the Grant family—including the wife of the former president of the United States, her children and grandchildren—to come and celebrate Thanksgiving. Together, they sat around a blazing fire while the feast cooked in its flames. Later, with the help of a young architect in San Diego named Irving Gill, Anna had a house built around her beloved fireplace. Her next purchase was a piano. To Anna Held, "Music breathes what the poet cannot write." Being the kind of person she was, she wanted to share her delight in music with friends and with the community. The piano was too large to fit inside the fireplace house, so she carefully covered it every night with a tarpaulin after practicing. One day, she placed a notice inside the post office inviting everyone to come hear music at her property. The two Miss Scripps, Ellen Browning and Virginia, who were about to build "a large house just a little further down the coast"; the Portuguese fishermen from Long Beach (now La Jolla Shores) and their families; a German farmer; the grocery man and his wife—in sum, everyone in the community, rich and poor—came to hear the concert. The magic of music leveled out the society.

After this first concert in La Jolla, Anna began building little homes on her property. The "little community" would be called the Green Dragon Colony, named after a story written by Miss Held's friend Beatrice Harraden (1864–1936).

A native of England, Miss Harraden had spent several summer holidays lodging at the Green Dragon Inn at Little Stretton, in Shropshire, walking and writing. Her memories of this and the landlady, a Mrs. Benbow, led to her writing a short story, "At the Green Dragon," published in 1894 as one of the stories in a collection called *In Varying Moods*, published in England by Blackwood and by Putnam in the United States. In the story, there is a Green Dragon Inn. The following is a description of Miss Harraden from the *Sandusky Register* in 1894: She is "a wee bit of a brown woman, with the strength of a canary, the frank, lovable ways of a child and the feeling of an intellectual giant."

Anna Held greatly admired Miss Harraden's work and especially this story and hence chose to name what would become an artists' mecca, the "Green Dragon Colony."

For Beatrice Harraden, coming to California was her definition of health. In 1896, after almost a year spent in the United States and just before her steamer, the *Lucania*, set sail, she was interviewed by the *New*

York Sun: "California, I think, is the proper place to go for anyone who is at all delicate. The climate is something wonderful. I had hardly been out there a week before I began to feel its bracing effects. I intend to return next Spring and I shall go to California for an indefinite time." She also was quoted as saying that the "western people are very interesting." Hence she thought she had "plenty of material for stories while she was among them."

An account of the history of La Jolla published in 1908 states, "The atmosphere of La Jolla is distinctly artistic and literary. Here live Rose Hartwick Thorpe, author of *Curfew Must Not Ring Tonight*, and other well known works, Anna Held, now wife of Max Heinrich, owner of the Green Dragon; and other celebrities." (Once married, in those days, one can assume it was obligatory to change the ownership from Anna's name to that of her husband.) The news clip goes on to say, "The place is beloved by artists, who draw and paint the many-colored cliffs with the ocean and brown hills keeping sleepless guard; by invalids who find the sea breezes, equable temperatures, and safe sea-bathing invigorating; and by lovers of quiet, who find its peace satisfying. It has attractions for the naturalist, also,

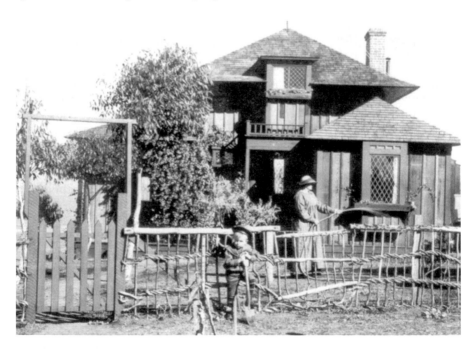

Anna Held's home Wahnfried, expanded from her first building, circa 1900. *Copyright La Jolla Historical Society.*

in the rare and beautiful algae and other marine growths found in the waters at the foot of the cliffs."

Beginning with her first cottage designed by Irving Gill, ultimately, there would be "lucky thirteen" cottages with names like The Ark (shaped like a boat), The Barn, The Wigwam, The Gables, The Tent and so on. Miss Held personally designed all of them and often helped build herself. All were constructed for her visiting artists, musicians, singers, architects, teachers and actors from Europe and England, including Dame Ellen Terry (English Shakespearean stage actress and one of Anna's best friends), Madame Helena Modjeska (Polish thespian considered one of the greatest tragic actresses of her time, especially in Shakespearean plays, who moved to the United States after 1876), Ignace Jan Paderewski (also Polish, a pianist and composer, politician and spokesman for Polish independence who purchased property in California just prior to the outbreak of World War I) and Max Heinrich. And as to the latter, it was in 1904 she fell in love.

A famous Chicago singer with a deep baritone voice, Max Heinrich, was in Coronado to perform a concert. But he had heard about the Green Dragon Colony and decided to go up to La Jolla for a visit. Anna Held was absent when he arrived. Accompanied by his daughter, he decided to sit at the piano that Anna cherished. So it was here, around Anna's beloved piano, where her artists' colony really began. Max sat down and began to play. His daughter, Julia Heinrich, who had a rich contralto voice, was standing to the side, humming. When Anna returned, she heard the lovely music. "Listening, unseen, she knew, although she did not immediately perhaps acknowledge this fact, even to her innermost self-consciousness—that the unexpected had happened." The staunch, big heart that so long, so often and so successfully had resisted the onslaughts of Cupid, had slipped from her keeping. The next day, Max Heinrich, who also fell in love at first sight, proposed marriage. He was told to return at Christmas and receive his answer. He did return to Coronado to fulfill his concert tour, but long before Christmas, he came back to La Jolla. "Yielding to the impetuous wooing of her lover, Miss Held allowed herself to be driven to the English Lutheran Church, where the 'double ring' service speedily made the two one" reported the *Los Angeles Herald* on December 4, 1904. Wheeler Bailey served as best man, and Madame Modjeska was Anna's attendant.

It is said that Max's "numerous progeny descended on the Green Dragon. Charming, talented girls they were, but—like their father—they had little conception of the value of money." So, besides guests, Anna began renting the cottages. This stimulated a good income. She also opened a tearoom

"where the weariness, the fever, and the fret" of modern life would seem dim and distant. Her motto for the Green Dragon Colony was "If you prefer the picturesque to the conventional, atmosphere to style; if care for individuality that is gracious, informality that is refined; if you know that art is a necessity, not a luxury in life, that beauty is a food and drink; if you are one of these…the Green Dragon will cast its subtle spell on you."

Soon after their marriage, Anna and Max decided to return to Europe for a visit. They wished to introduce each other to family and friends. Anna sold part of her property to provide for the trip, as they preferred staying in first-class hotels and sailed on an expensive ocean liner. One day, when they were in Germany, the police came to their hotel and knocked on their door. It seemed that Max had not served in the military some thirty years before. Max explained that he was young when he left Germany and came to the United States and had become an American citizen. Then the police said he was required to have a visa, limiting the length of his visit to three months. Max returned to the United States while Anna remained to visit with more family and friends. It appears Anna and Max never reunited. While he was on the East Coast of the United States performing, he became ill and died in 1916.

Anna made several trips back and forth from La Jolla to Europe, but she became quite exhausted being so conscientious about keeping her patrons comfortable and promoting her beloved colony of cabins. So, in 1912, Anna Held Heinrich sold the Green Dragon Colony for $30,000. This was the largest real estate transaction in its day. The land had cost only $165, then with the construction of cabins, the cost amounted to a mere $2,165—a wonderful investment for Anna.

Anna moved to a cottage on Torrey Pines Road, not too far from her beloved Green Dragon Colony but down the hill. H. Hubbard records her transition in *The Joyous Child*: "There was a little triangular lot on the boulevard leading northward out of La Jolla, near the junction of the street that led down to the ocean and to Wheeler Bailey's much-talked of house. This Anna Held bought and there she erected a helter-skelter house much as she liked and put up a tiny cabin as a guest place nearby. Into the larger structure she moved her grand piano and certain of her personal belongings and Green Dragon Junior was established." It is believed the "helter-skelter" house was a mail-order Sears Roebuck modular house, and it is said that after the construction of the house, Anna wished to have a bathtub installed.

A little aside—there were no bathtubs at all anywhere in the United States until sometime after 1840. It was the physicians who opposed the practice of bathing in tubs as being dangerous to public health. Laws were passed in

most states and cities prohibiting and discouraging the use of bathtubs in private homes or hotels. The Commonwealth of Virginia even passed a law taxing the owners of bathtubs the sum of thirty dollars per year. In some places, it was against the law to take a bath without the advice of a physician. The end of World War I resulted in a housing construction boom in the United States and a new concept, the purpose-built modern bathroom. Bathrooms prior to World War I were typically converted bedrooms or spare rooms, not rooms built originally to contain bathroom fixtures. Complete with toilet, sink and tub, the modern bathroom was a feature of 100 percent of new homes by the end of the twentieth century, whereas only 1 percent of homes had had bathrooms in 1921.

But back to Anna Held. The bathtub would not fit into her cottage. So Anna had it placed on the back porch, or rather, half on the porch and half on the inside. The cottage was downhill from the Torrey Pines Road, so if you were walking by, you might look down and see Anna bathing in her tub.

Tante Heinrich, as she was fondly called in those latter years, loved visitors and entertained many friends in this little helter-skelter house. The list of invitees includes musical and literary artists of Southern California as well as others like John Doane, the New York organist with whom she had taken many trips to Europe.

But, reluctantly, in the late 1930s, Anna left La Jolla. Because of Hitler, she could not return to Germany, so she went to live with an old friend in London. On December 14, 1941, Anna Held Heinrich died at the age of ninety-three.

Wheeler J. Bailey

The Father of Good Roads in San Diego

*I*n 1916, it was dry, so dry that San Diego hired a rainmaker. The result was too much rain and flooding. Mrs. Helen North Reynolds was a boarder at The Bishop's School at the time. She recalled that since transportation was so difficult because of the flooding, the school had run out of many necessities. Helen's great-uncle Wheeler J. Bailey was a trustee of the school and Miss North's guardian. He called Headmistress Caroline Cummins to ask if she needed anything. "Butter," she replied, so Mr. Bailey brought her a pound of butter. He did not realize it was for the whole school!

Born in Ohio, the Western Reserve, Wheeler J. Bailey came to the area of San Diego in 1888. He was a pharmacist by training, but it was not long before he recognized the tremendous growth that was taking place in San Diego and got into the building supply business. For over forty-eight years, the Wheeler J. Bailey Company supplied material (including regionally derived cement) for just about every important building in San Diego, from the Hotel Del Coronado to the original San Diego Exposition buildings of Balboa Park in 1915. (Note: The company survived the death of Mr. Bailey and continued up to the late 1950s.) A contractor as well, architect Irving J. Gill became both a loyal client of the Bailey Company and, in time, a good friend to Mr. Bailey. Although his store was a freestanding building in Little Italy, the western downtown area of San Diego, his residence was the Lanier Hotel (designed by Hebbard and Gill) in San Diego. (Beginning in 1896, Gill had a ten-year-long working relationship with William S. Hebbard.)

Wheeler J. Bailey. *Courtesy of Thomas Mitchell; from* Reviewing the Vision: A Story of The Bishop's School, *published by The Bishop's School, 1979.*

In 1907, Mr. Bailey decided to have a home built on the bluffs of La Jolla, and he chose Irving Gill to design the house. Frank Mead (1865–1940), another architect described as a "free spirit" (born in the hometown of another free spirit, Walt Whitman, in Camden, New Jersey), assisted (as a partner to) Mr. Gill on this and a few other projects. Mr. Bailey wanted his house to resemble a barn. To produce this effect, the architects created a double-height wood-paneled living room with an open second-story balcony-hallway that served to connect the loft-like bedrooms on two sides. Huge barn-like sliding doors open onto the front terrace. At the rear, a series of windows overlooks the Seven Sister Caves and the pounding surf of the La Jolla shore line. The exterior is stucco with blue-green trim.

Bailey actively participated in the construction of his La Jolla home, initially to be used as a weekend retreat. Eventually, he made it his permanent residence. The furniture was simple Craftsman style, some of it designed by Mr. Gill and Mr. Mead. Not afraid of color, Mr. Bailey chose brightly colored Indian rugs and artifacts. At the urging of both Gill and Mead, the Steinway piano was painted red, according to the January 1914 edition of *Craftsman* magazine. Bailey said, "I confess I rebelled when they [Gill and Mead] suggested it…a red Steinway! It seemed a sacrilege; but at length, I agreed." Since Mr. Bailey did not like the fancy legs, "he had them boxed, creating cleaner lines consistent with the rest of his house." The house was selected as one of forty in America for its interior design.

In addition to his supply company, Wheeler J. Bailey was vice-president and later president of the Summit Lime Company of Los Angeles, vice-president of the Citizens National Bank of San Diego and a member of the Army and Navy Committee. Always interested in the welfare of his community and a member of the highway committee, he is often called

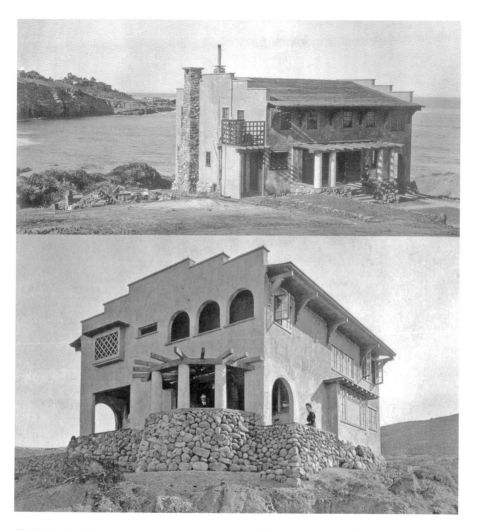

Top: Wheeler J. Bailey's house, designed by Irving Gill, under construction, circa 1907 *Courtesy of Thomas S. Hines; bottom:* The finished house. *Courtesy of Pinterest.com.*

the "father of good roads in San Diego" because of his interest in laying out roads and the building of fine highways. Other interests included many philanthropies, especially the welfare of American Indians, many of whom came to work for him. Some of the art and artifacts he collected from the Indians are now in the Museum of Man in Balboa Park.

Although he remained a bachelor, Mr. Bailey undertook the guardianship of his young great-niece when her mother died. Helen had lost her father, Edmond North, when she was two. He had been wounded

in a mining accident in Mexico. Helen had been left with help in Mexico while her mother accompanied Edmond to get medical help in the United States, but he died before they arrived. Initially, Helen's mother came with her daughter to stay with Uncle Wheeler. Later, she went back to Nevada, where Helen had been born, and remarried there. She died when Helen was twelve, and the child came back to live with her great-uncle, whom she adored. Bailey was adored by all the members of his family and by the whole community as well. "Uncle Wheeler" loved people and was host to many men and women of note in the scientific, artistic and literary worlds. His great-niece remembers meeting fascinating people from all over the globe and has the guest book to prove it.

Mrs. Reynolds reminisced, "Every Sunday, Anna Held, a wonderful old lady and a dear friend of my Uncle," would come for dinner. Often, Anna would play the piano, and "Uncle Wheeler liked to sing along."

Eventually, Mr. Bailey's house received its official name. It was called Hilerô, the local Indian word for cliff. The dedication was performed by the actress Madame Helena Modjeska. Since Wheeler Bailey was such a philanthropic patron of the arts, his guest list increased over the years, so much so that Mr. Gill was eventually commissioned to design two additions to the house.

Beginning with the first building constructed at The Bishop's School in 1909 and designed by Irving Gill, Mr. Bailey had close ties with the school that his great-niece came to attend. According to Erik Hanson, Bailey was "most probably on the selection committee (hence the selection of Irving Gill) and surely was the school's financial representative with the architectural firm." For twenty-four years, Wheeler Bailey continued as a trustee of The Bishop's School and acted as its treasurer. The cornerstone of the school's library, which bears his name, was laid in 1934. Unfortunately, he never saw its completion.

Wheeler J. Bailey died on March 6, 1935. An eccentric of sorts, Mr. Bailey was also one of the patron saints of La Jolla and another example of "so few people, but what they could do!"

6

The Story of La Jolla by the Sea

By Austin Adams

*P*laywright H. Austin Adams built his house on Park Row Circle in 1908, having come to La Jolla from New York. The following is his account of his first experience in La Jolla, written in the 1920s.

In the Spring of 1907, it was, that I discovered La Jolla and at once decided not to die just yet. I was sick, worn out, all in, and had fled from the cold and clouds of the North to the warmth and sunshine of the South. Not that I hoped to get well—I knew I must die—but it would be so much nicer to die in sunshine than in gloom. Then, one day, I was taken out to La Jolla—and I'm not dead yet! I called off my "rendezvous with death," built me my little "Dreamery" on the hill, took a fresh hold on life and hope, and started in to enjoy the twelve happiest and most inspiring years of my strenuous and adventurous half-century. La Jolla did it! La Jolla, matchless in all the world for beauty and restfulness and the "peace which passeth understanding"—unless one be both poet and philosopher. I, thank God, am both.

And such a quaint, unique, delightful village La Jolla was in those days—different from any other spot on earth—with its picturesque little bungalows clinging in clusters, any old how, to the cliffs and the hillsides; its winding footpaths in lieu of sidewalks; its primitive simplicity; and over all, its wistful spell of beauty, beauty so exquisite that it almost hurt! But it required no Prophet's eye to foresee the day when such transcendently lovely building sites would be crowned by stately villas, and La Jolla came

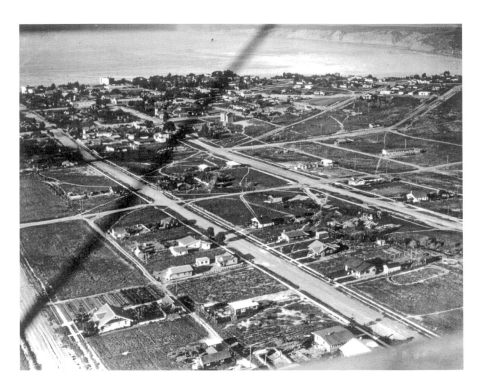

Aerial view of La Jolla, 1920. The two main streets (upper left to lower right) are Fay (near) and Girard. The cross street is Pearl Street. *Public domain.*

into her own as the choicest residential spot in all America. That day has arrived. And the migration has only just begun. From the four quarters of the land will continue to come those who once see La Jolla, because to see it, is to register the vow to come back, some day, to settle and really begin to live.

7

Ellen Browning Scripps

Philanthropy Defines Her

\mathcal{E}llen Browning Scripps was born in London on October 18, 1836, at 13 South Moulton Street. Her father, James Mogg Scripps (1803–1873), was the youngest of six children born to London publisher William Armiger Scripps (1772–1851) and Mary Dixie (1771–1838). He was an "improvident," though greatly admired, bookbinder from an otherwise distinguished family. Ellen was one of six children (although the first born to Mary and James died at the age of six months, there was a daughter from her father's first marriage whose mother died just months after her birth) and was only four when her mother, Mary Saunders Scripps, died. James Mogg's business was already becoming obsolete with the introduction of mechanical binding, so it did not take much for his father to talk his son into taking the children and moving to America. Consider "the boundless opportunities," William Armiger Scripps told his son. He considered an area where some of his kin lived as "very healthy and dry and free from mosquitoes, situated on a prairie, with extensive woods behind it….Business to any extent could be carried on here at enormous profit." Plus, "[T]hink of the children." Although he was a bit reluctant, James Mogg Scripps did consider the move a solution to his worrisome financial condition. So, in 1844, Ellen's widowed and now almost bankrupt father immigrated with his six children to Rushville, Illinois.

Much of the voyage was a nightmare. From the sometimes stormy high seas on board the 108-feet-long by 28-feet-wide *Francis Barr*, a three-masted sailing ship, to the muddy terrain on board two covered wagons, each pulled by two horses with the children sitting on top of the luggage, sixty-two

days after leaving London, they arrived in Illinois. The James Mogg Scripps family finally settled on 160 acres of poor farmland bequeathed to him by his father just outside the small town of Rushville.

Soon after their arrival, unable to properly care for his children, the oldest of whom was too young to take on the role of surrogate mother, James Mogg married Julia A. Osborne. Julia bore him five more children, one of whom, the youngest, born in 1856, was Edward Wyllis. Ellen's favorite, Edward later became one of the foremost journalists in the United States. Throughout his life, he stayed close to his half-sister Ellen. She was eighteen years his senior. (Edward died on March 12, 1926.) With all the new children born into this second marriage, it was Ellen who spent much of her youth helping care for her younger siblings, doing their laundry, cooking and reading to them.

During those early days in Illinois, Ellen slept on a bed with a mattress made of corn shucks. Life was simple. But eventually, things would change. Ellen loved reading, and the books she chose were classics. After attending several public and private schools, she taught school to save money for college, earning nine dollars a month. (Male teachers received thirteen dollars a month.) Ellen matriculated at Knox College, not far from the family's Illinois farm. While there, she witnessed one of the Lincoln-Douglas debates. This inspired in her a lifelong interest in politics and free speech. However, as women could not receive college degrees from Knox, Ellen received instead a certificate after completing a two-year course in 1859. (However, some sources say she graduated and was one of the first female college graduates in the United States.)

After Knox, Ellen returned to Rushville to help care for her aging father and returned to teaching. Then the Civil War broke out, and Ellen contributed to her first charity, the Freedman's Association, by volunteering.

But once again, life changed dramatically for Ellen. She began working for her elder brother James and her younger half-brother E.W. in the newspaper industry after saving enough money in invest in their paper. Their first newspaper endeavor began when her brother James Edmund became an owner and publisher of the *Detroit Tribune*.

In 1865, James convinced Ellen to take a job as a copy editor. In 1873, work for the *Detroit Tribune* ended when the company's building burned to the ground, but the brothers secured a handsome insurance settlement. After five years in Detroit, Ellen returned to Rushville to care for her ailing father. Meanwhile, the brothers began a new paper. The *Detroit News* was an innovative penny paper for workingmen printed as an afternoon edition.

After her father's death, Ellen rejoined her brothers in Detroit and began working as a proofreader, copy editor and writer. One of her columns was "Matters and Things," addressed specifically to women. Soon their brother George also invested in this venture, having sold the family farm.

When E.W. Scripps left Detroit to establish his own newspaper chain, Ellen invested in his company and eventually owned substantial stock. In 1881, she traveled to Europe and North Africa with her brother and wrote back to the newspaper details relating to the lifestyle of the people she encountered in various countries, thus becoming one of the first female foreign correspondents. (Margaret Fuller, who wrote for the *Tribune*, was actually the first female foreign correspondent.) Ellen's column was called "Miss Ellen's Miscellany." She later traveled back to Europe, then to Mexico and Cuba with her brother James. She also became involved with many revolutionary (at least, at the time) movements like labor union disputes, temperance societies, dress reforms and educational changes. In 1873, Ellen joined the Suffragette Association.

Ellen had now earned a reputation as both a talented journalist as well as a brilliant businesswoman. When her brother E.W. retired in 1890, he moved to California, an area he had visited with his new bride, Nackey Holtsinger. E.W. had been experiencing ill health and was looking for a warm and dry environment. The climate in the area east of La Jolla agreed with him so much that he purchased and built a farm, which he called Miramar since he could see the sea from his property. In 1891, Ellen went to stay with him, but she loved to travel to the coast. E.W. created a road for her almost daily trips. Ultimately, her brother encouraged Ellen to build a home for herself.

Her first house, the first home she had ever owned, was built for her when she was sixty-one years old. She named it South Moulton Villa after

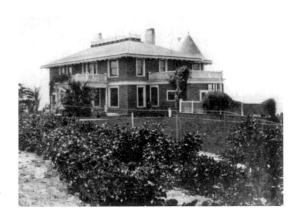

South Moulton Villa before it burned to the ground, built 1897. *Courtesy of Alchetron.com.*

the street in London where she was born. Constructed in 1897 by Thorpe, Kennedy & Johnson, the house had a prominent cupola and overlooked the rocky shoreline. Built of redwood, it was a modest and unpretentious building and included two small cottages in front. One cottage was for the collection of books she had accumulated, the other for guests. The lovely gardens around the house were designed by Kate Sessions, and La Jollans were always welcomed by Miss Scripps to enjoy the parklike grounds.

She loved her home and loved being by the ocean, where she could hear and smell the surf. She even slept on the porch in the back of the building. But in 1915, the house burned down. The good news was that the two cottages were saved, one with those precious books, the other in which her niece, Ellen Clark (later Revelle), would one day be born.

Sadly, it was arson. This came as a shock to Ellen, who had spent her life helping people. William Peck, forty-one, had been discharged as a gardener on the Scripps grounds almost a year before. He admitted his guilt, saying he was too drunk to know what he was doing. Plus, he said, he had no grudge against Miss Scripps. It was the housekeeper who had fired him and thus instigated his grudge and action.

The architect she had used for the construction of the Woman's Club, Irving J. Gill, was asked to build a new home for Ellen. To avoid another fire, it was made of concrete and stucco, very modern for 1916. It now houses the Museum of Contemporary Art.

E.W., who still lived nearby in Miramar, advised Ellen to make plans for the utilization of her money, money she had earned with the success of their newspaper business. At this time, her yearly income was $700,000. She also had inherited stock in the *Cleveland Press* from her brother George Henry Scripps, who died in 1900. A great deal of thought and planning was needed to maximize the use of these funds. As a legacy to her late brother, a yachtsman with scientific interest, Ellen met with Dr. William Ritter, a Berkeley biologist who was looking to start a research center in Coronado. After meeting with Dr. Ritter and attending several of his lectures, Ellen decided to contribute $1,500 a year toward the establishment of a marine station at La Jolla Cove. In 1906, she provided an endowment of $50,000. Then, in 1907, she gave $1,000 toward the purchase of a La Jolla Shores site for the marine station. And in 1909, Ellen made a bequest of more than $250,000 to the station, which allowed for the building of the pier, the roads, the first laboratory building and the first library of Scripps Institution of Oceanography. In fact, along with her brother E.W. Scripps and his son Robert Paine Scripps, the family was able to provide an annual

subscription to the institution, which constituted the entire operating budget for the marine station from 1903 to 1912. (For more on Scripps Institution of Oceanography see chapter 15.)

Ellen Browning Scripps always loved children, and many of her plans included the little ones. One of her most popular projects was the Children's Pool. It was Ellen's desire that the children of La Jolla have a safe place to swim. In a little cove near the Casa de Mañana, Miss Scripps had a breakwater built using some of the rocks that washed up on the shore. Completed in the spring of 1931, on May 31, at an elaborate ceremony, Mr. Jacob C. Harper, representing Miss Scripps, presented the pool to the city in her name, adding, "Adults must recognize that here at the pool, the children have a primary claim." It now belongs to a seal population, and children are cordoned off from most of the beach and the ocean.

The San Diego Zoo has also been a recipient of funds for projects that provide joy and educational experiences for children. Every October, the *ZoonooZ* acknowledges the birthday of Ellen Browning Scripps. Douglas G. Myers, executive director, wrote in the October 1998 issue, "This wonderfully generous lady, and the Ellen Browning Scripps Foundation that she left as her legacy, have provided The Zoological Society of San Diego over the years with more than $1 million in support for the San Diego Zoo, the San Diego Wild Animal Park, and the Center for Reproduction and Endangered Species (CRES). But it is not the dollar amount we pay tribute to each year; it is the history of consistent giving for which we celebrate Miss Scripps and her foundation." He goes on to list the many items that were donated or bought for the zoo over the years, beginning with 12,500 linear feet of wire fencing for the zoo's two hundred acres of grounds in 1922. Consequently, admission could be charged. The first admission prices went into effect on January 1, 1923: ten cents for adults. The Scripps Flight Cage, the zoo hospital (built in 1926, it now houses CRES) and, as the tradition continues, "almost every new exhibit built at the zoo in recent years" have been built thanks to the generosity of Ellen Browning Scripps and the Scripps family.

Opened to the public on July 3, 1915, the La Jolla Playground was a prototype for public playgrounds throughout the United States. One of the plaques on the building indicates how appreciative the children of La Jolla were for the consideration and generosity of Ellen Browning Scripps. It reads, "THIS TABLET IS PLACED HERE BY THE CHILDREN OF LA JOLLA WITH LOVE AND GRATITUDE IN HONOR OF ELLEN BROWNING SCRIPPS, THE DONOR OF THIS PLAYGROUND A.D. 1915."

Original birdbath and the little child statue presented to Ellen Browning Scripps by the schoolchildren of La Jolla. The sculpture was by James Tank Porter, 1930. *Copyright La Jolla Historical Society.*

At her own home across the street, Miss Scripps kept a shelf of toys and always allowed the local children to ride their bikes on her walks and play in her garden. When asked why she had ten gardeners and only a weekly cleaning woman, Miss Scripps is said to have replied, "La Jolla has no park, and I have all this space here. Hundreds of people walk through my garden every week. It is always open to the public, and when I divide what it cost me by the number of people who enjoy it, I think it is one of the most economical civic duties I could perform."

Although she was given many awards by people and organizations, one that touched her deeply was the presentation of a stone bench and a birdbath with a statue of a little child scooping water into her hands for the birds to drink. All of the local schoolchildren contributed a penny toward this gift. It was placed on the lawn in front of the Recreation Center Building (which she had donated). In the mid-1990s, the little statue was stolen, to the great sadness of the community. On June 28, 1997, La Jollans replaced the little figure with a new statue.

La Jolla High School was the recipient of an athletic field, and The Bishop's School received its share of gifts from Miss Scripps as well.

"I am convinced that there is nothing so fundamental—and hence so vital—to the service of people as true education," she said in response to a request from President Blaisdell of Pomona College. Ellen Scripps had always been concerned about women and their education. President Blaisdell's dream had been to establish a group of small associated colleges in Claremont. Miss Scripps was happy to help make this dream a reality, but she was not pleased with his using her name for the new college for women. Not only did she detest personal recognition, she declared that Scripps was "a ridiculous name, without melody or charm, with its one futile vowel flanked by its six Nordic consonants."

Since she could not make the trip to the college, the first class and faculty came to her. She surprised them all when she was able to call each by name and make a pertinent comment. She had done her homework. As to her hopes for the new college, she said, "I like to picture a college whose motto is not 'Preparation for Life' but 'Life' itself."

In 1926, Miss Scripps graced the cover of *Time* magazine. The editors introduced her as "a woman who taught school when Lincoln was a country lawyer, who helped found a newspaper in 1873, and who [now] founds a college [Scripps College for Women] at age 89. Miss Ellen has always regarded her wealth as a trust for the benefit of humanity. She has made giving an art."

Other local gifts include the La Jolla Woman's Club (for grounds and building and membership dues for anyone not able to afford it), the Torrey Pines State Reserve (acreage and lodge), the public library, the Scripps Institution of Oceanography, Scripps Metabolic Clinic, the Nurses' Home, Scripps Memorial Hospital, Scripps Cottage at San Diego State University, the San Diego Natural History Society, the world's largest aviary at the San Diego Zoo, the St. James Episcopal Church chimes and donations to every church in La Jolla.

Apropos Torrey Pines, in 1999, Torrey Pines State Reserve celebrated its anniversary. After Miss Scripps's death in 1932, the property she owned at Torrey Pines was transferred, as per her instructions, to the city. Known

Torrey Pines Lodge and Coastal Highway. *Courtesy of Judy Schulman.*

as "Torrey Pines Park," it was the first area within an urban setting in the nation to be designated as a natural preserve.

During her last thirty years, Ellen Browning Scripps lived as many older women did in this little community. She joined the various local clubs, played cards, took part in plays, held open houses weekly and traveled around California in her Rolls-Royce driven by her chauffeur, Fred Higgens. The car and driver were a gift from her brother E.W. Scripps.

In an interview with Mr. Higgens in 1965, Miss Scripps's chauffeur shared some insight about this special lady. Asked what time she usually got up in the morning, Mr. Higgens replied, "Oh, she'd get up anywhere after 4:30. Something like that. She would get up as soon as it got daylight you might say. She'd go right down to her office desk [after] getting out of that old cot that she had. I had a hood made for her, you know, waterproof canvas. She'd get up in the rain and pull at that canvas out there….Of course, she had her bed she never slept in. I think it had to be an awful big rain to move her in. She loved the outdoors. She loved to sleep out on that porch." It seems that Miss Scripps slept out on that porch summer and winter. However, one morning, when she got up and attempted to make her bed, she fell. "You see she always made her own bed," Higgens continued. "That was when she stepped on the blanket. She was pulling the blanket up to get it straightened out and slipped." It took hours for someone to find her. Fred Higgens and his brother carried her down the street to the Kline House, which housed the little Gillespie Sanatorium. Scripps's stay there made her realize La Jolla needed a bigger and more modern hospital. In 1923, grounds were found and dedicated to the construction of a fifty-seven-bed hospital. The Gillespie Clinic was moved, and on September 26, 1924, the Scripps Memorial Hospital opened.

Always inquiring, always learning, she said, when well over ninety, "Of course I know I may die any time. I do not fear death, but I should like to live a little longer to see [she mentions many issues of the day]….Oh, life is just beginning to be so very interesting!"

Nevertheless, the inevitable did happen. Just three months prior to her ninety-sixth birthday, Ellen Browning Scripps died, on August 3, 1932. Her ashes were scattered off the coast, just within sight of her old vantage point, the sunroom at South Moulton. (On an amusing note, Roger Revelle told his wife that the captain apparently forgot to lick his fingers before he held them up to check the wind direction. Her great-aunt Ellen's ashes actually blew back onto the little Scripps Institution vessel used for the ceremony.)

Unselfishly, Ellen Browning Scripps gave of herself and her wealth for the care and betterment of mankind. She was a human being who

embodied all that is good and was a role model for all of us. We are so lucky she chose to call La Jolla "home."

In her own words, "If one could live one's life over again with the advantage of the experiences one has gone through, it might be interesting as an experiment—not as a pleasure."

On the anniversary of what would have been her 100th birthday, a tree was planted for her in the park that bears her name, with the following plaque:

> *THIS TREE WAS PLANTED BY*
> *ELEANOR B. PARKES*
> *OCTOBER 18, 1936*
> *THE 100TH ANNIVERSARY*
> *OF THE BIRTH OF*
> *OUR BENEFACTRESS*
> *ELLEN BROWNING SCRIPPS*
> *FOR WHOM THIS PARK IS NAMED*

Apropos Miss Parkes, a group of artists used to meet in La Jolla and spend time making sketches, closing the day with a visit to the home of Ellen Scripps. Miss Scripps would serve tea and view their artwork with interest. On one of these occasions, in April 1918, Eleanor Parkes conceived the idea of having an art organization in La Jolla for both artists and laymen. With Miss Scripps's blessing, the La Jolla Art Association was formed with Mrs. Parkes selected as its president.

Miss Scripps's home, now the Museum of Contemporary Art (MOCA). *Courtesy of www. fivedayrental.com.*

In her will, Ellen stipulated that her executors seek a public use for South Moulton Villa. It was, she said, "a community asset" since it was located amid churches, the community playground and the Woman's Club. She allocated funds for its maintenance for a ten-year care program or until a buyer was found for public use. Unfortunately, the timing was bad. Following World War I, the United States experienced the Great Depression. It wasn't until after World War II that the real estate market finally regained its health.

Finally, in 1940, the La Jolla Art Association, following an exhibit of its members' works inside one of the rooms in South Moulton Villa, decided to purchase Ellen's home. Hundreds of thousands of dollars were raised without going outside the La Jolla community. In 1941, the villa became the Art Center. This was most appropriate, since the Art Association of La Jolla had been formed in Miss Ellen's living room in 1918. After many changes and additions to the original structure, ultimately, in 2000, it became the Museum of Contemporary Art.

La Jolla Woman's Club

One of Miss Scripps's many gifts to the citizens of La Jolla was the La Jolla Woman's Club. Founded in 1892, the woman's group was originally called the "Current Events Club." Two years later, the group named itself the "Woman's Literary Club." Another two years passed, and the name was changed yet again, this time to the "La Jolla Current Events and Reading Club." Each change incurred a rewrite of the club's constitution. Ultimately, on March 29, 1899, it was renamed "La Jolla Woman's Club," and the group was incorporated as such in 1914.

In 1902, the La Jolla Woman's Club was the first in California to affiliate with the General Federation of Woman's Clubs in America.

Aware of this group, Miss Scripps requested again the "genius" of architecture, Irving J. Gill (1870–1936), to construct a permanent home for this group of women. The building was completed in 1914.

Mr. Gill incorporated "tilt-slab" construction, an innovative technique at this time. This process allows the sides of the building to be formed by pouring concrete in a frame on top of the foundation floor, which was then lifted to create the walls. (According to the Internet, what is now called "tilt-up" construction is one of the fastest-growing industries in the United States. At least ten thousand buildings enclosing more than 650 million square feet are constructed annually.) Using this technique, Mr. Gill created a building devoid of embellishments that reflects simple lines, including his traditional arches, which frame the wraparound porch and a vine-covered pergola that extends to the street. This latter design was also used in front of the cottage that once was to the right front of Miss

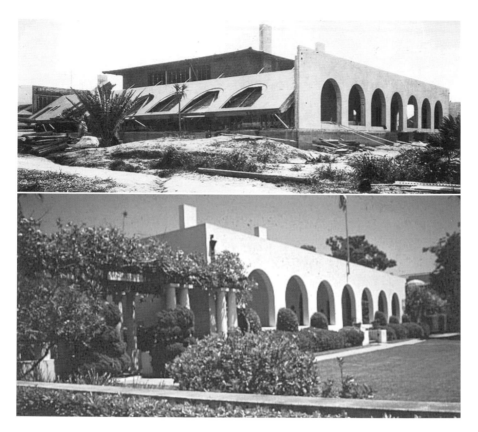

La Jolla Woman's Club. The top image shows the methodology of Gill's tilt-up slab construction. *Top, courtesy of www.ou.edu; bottom, courtesy of* La Jolla Blue Book.

Scripps's home, as well as the entrance to the Wisteria Cottage, which Mr. Gill redesigned and repositioned on the lot to accommodate Miss Scripps's sister Virginia next door.

It is hard to believe, but in the early days, there was a cow staked out on the wild grass in front of the Woman's Club. Sid Gaines and his wife, Daisy, who had been the bookkeeper for Harrods in London before coming to La Jolla in 1912, were the caretakers of both the club and the cow. Once a day, Mr. Gaines would milk the cow and take some of his collection to Miss Scripps, who lived across the street.

At the December 1913 dedication ceremony, when the cornerstone for the Woman's Club was laid, Miss Scripps was asked to "draw a pen picture of the future of La Jolla." What she submitted is the following article, some of which was originally written in 1899. A copy of this article was placed behind the cornerstone at its dedication:

The Future of La Jolla

I have been asked, as I understand it, to draw a pen picture of La Jolla's future. I am neither prophet nor poet, and my instincts all tend to the practical consideration of the actual, not the ideal.

That there lies before us great possibilities, there can be no doubt. Wealth, subordinate to art and culture, may create a suburb of stately homes environed by beautiful parks and avenues of tropical luxuriousness; may produce a fitting jewel to the setting that nature has provided in her picturesque coast line backed by the illimitable, eternal sea, with its every varying, wondrous colors and moods and aspects; the radiant sky above and the mountain tops afar off.

It is easy to conceive such conditions, it is harder to construct them, and yet it must be in the consideration of such building up that we are chiefly concerned today.

In this practical, prosy, every day world of ours it is only labor that wins success; the labor no less of thought and education and brain culture than of brawn and muscle.

Something is never made out of nothing, good people of past generations to the contrary, notwithstanding.

There can be no evolution without involution; no bringing forth, without first putting in. It is through the travail of the artistic soul that beauty is born. Patience and labor are the essentials, not the mere incidents of success; not the labor that is sordid, but that, that is loving and intelligent; not the patience that means idle waiting, but that, that imitates the Divine Creator in His construction of the universe. The fruition of our hopes and aspirations can be attained only by our own determination and acts.

I hesitate even to suggest practical ways and means for the prosperity we seek.

What has become of the Village Improvement Society? Is it buried beyond resurrection? Have its rules and ordinances become a dead letter? Are not such matters as cleanliness, orderliness and thrift within its province? Is there not comprehended in its duties the repairing and keeping in order the streets, boulevards and avenues of the village; the enforcement of the stock law, the securing of water rights and privileges for the residents; the encouragement of rapid transit between suburb and city; the discouraging of unseemly sports and practices from outsiders; the prohibition of injurious acts, demolition of public property, desecration of natural scenery, etc.? Do not these and other matters seem essential factors of prosperity?

Individually, much may be done, as witness the comfort and conveniences and facilities of mental and social culture afforded in the building we now occupy. But it is in the aggregation and union of will, purpose, energy and labor that new conditions are to be wrought and real satisfactory progress attained.

It lies with us residents and owners of La Jolla to make our "Jewel" what we will, only keeping it always in harmony with its glorious natural setting. To do this we must cultivate ourselves, in our own hearts and lives, the spirit of all harmony and beauty and spirituality. From the upbuilding of character goes the outbuilding of beauty.

It will matter little then if our homes are stately edifices or unpretentious cottages. For here the poet will find his inspiration, the teacher his lessons. Here the artist shall realize his dream, the weary and suffering shall find rest and solace, and every soul shall be satisfied; for it shall awake in the likeness of its Creator.

From La Jolla to Bird Rock the entire coast is beautiful, changing, majestic. There are numberless curious pieces of rock formation, gigantic in size, and varying as the sands in formation. Let the imagination but play among these rocks, caves and overhanging bars, let the various beauties but become beloved of the poet, painter and romancer, let them but receive the "honorable mention" that is their due, and Neptune's Garden at La Jolla will be a fair rival of Colorado's charming resort.

Not part of this article, but in what appears as a conclusion, Miss Scripps quipped, "This home is but a temporal foothold for the building up of a structure not made of hands, where if we will, where it shall dwell the true spirit of democracy, human justice and perfect companionship, out of which shall go forth that spirit of love and service which meets no barriers, knows no bounds."

9
Irving J. Gill, Architect

\mathcal{M}any of the buildings Miss Scripps commissioned for the community were designed by Irving J. Gill (1870–1936). One of six children, Gill was born and raised in Upstate New York, in a small farming community near Syracuse. His parents were Quakers, and Gill's faith played a major role in his development. The Quakers, also known as the Society of Friends, believe the spirit of God dwells within each of us. Individuals can, therefore, call on the "Inner Light" without the intervention of ministers or priests to discover truth. Their belief in individual rights and in simplicity were two "mantras" held by Gill and later emulated in his architecture.

Irving Gill did not go to college. After high school, he worked first as a gardener, then as an apprentice draftsman for an architectural firm in Syracuse. But he saw a more adventurous future for himself in the West—specifically, Chicago. He began with a former partner of the firm in Syracuse, Joseph Silsbee, who specialized in residential practice. But, in 1891, he moved to the office of Louis Sullivan in Chicago. Unbeknownst to Gill, Frank Lloyd Wright, three years his senior, had also transferred to Sullivan's in 1888 and was the chief draftsman at the time. He "hand-picked" Gill as one of his "squad." Sullivan admired Gill's understanding of how buildings were constructed, his belief in simplicity and his conviction of "applying democracy to architecture." Rather than imitating European architectural styles, he, and others like him, sought new ways to focus on building decent, affordable housing for all social classes. Its roots were in the Arts and Craft tradition.

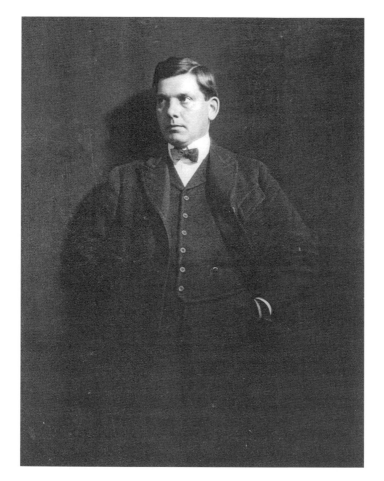

Irving John Gill. *Copyright San Diego History Center.*

After becoming ill from overwork (mainly having to do with the World's Fair held in Chicago in 1893), Gill moved to San Diego "seeking warmth and health" and began his own career. As a result of his exposure to Craftsman style and the Prairie School philosophy in Chicago, Gill's designs reflected an original and individual style of architecture. It was anti-ornament cubist design using innovative construction techniques like tilt-up walls. "There is something very restful and satisfying to my mind in the simple cube house with creamy walls, sheer and plain, rising boldly into the sky, unrelieved by cornices or roof overhangs....I like the bare honesty of these houses, the childlike frankness and chaste simplicity to them."

His buildings also provide excellent examples of the intersection of nature and architecture. "If we, the architects of the West, wish to do great and lasting work," he wrote, "we must dare to be simple, must have the courage to fling aside every device that distracts the eye from structural beauty, must break through convention and get down to fundamental truths." His walls were flat and plain, as Gill thought there was nothing more beautiful than the shadows cast on the wall by clouds or the silhouette of a flower. And no carving or fresco could give a more perfect appearance than a vine or creeper. Even the interiors emulated his philosophy. He believed in absolute sanitary and aesthetic cleanliness. He allowed for no ledges, as, he maintained, they collect germs. Floors were concrete and rounded into the walls, waxed and waterproofed so, again, no vermin or mold could creep in. The bathtubs and sinks were finished flush with the concrete walls, so there was nowhere for germs or grease to lodge. The kitchens had skylights that flared out at the bottom to evenly and amply light up the room. Gardens were also an essential feature of his homes. Additionally, Gill personally oversaw every aspect of construction.

In his own words, apropos the connection between the natural environment and art, "The one thing which seemed to bind artist and author, architect and craftsman alike, which seemed to hover over the entire creative community in both north and south was a strangely palpable sense of place—of the land and of the individual's identity with it. There was something new and pervasive about the quality of the western light. The benign climate brought an almost romantic consciousness of nature. There was a sense of timelessness, of being in a world apart—a world which could be remade in one's own vision—in which one's desired life style could be realized and one's influence felt."

Gill's first La Jolla project was not for Ellen Browning Scripps but for a young German girl, a governess. She had collected rocks around her newly purchased property and, placing them one by one, built a fireplace. But soon she wanted a cover over her fireplace, so she asked her friend to build it. Irving Gill designed what was to become the first of several cottages for Anna Held.

Gill was also interested in designing safe low-income housing as well as facilities for the everyday citizen. These latter projects were mostly represented by those Miss Scripps requested for the people of La Jolla like the Recreation Center (first called Community House in 1915), Bentham Hall and Scripps's Hall at The Bishop's School (1910) and the Woman's Club (1912–14), as well as Miss Scripps's second home (which, after her

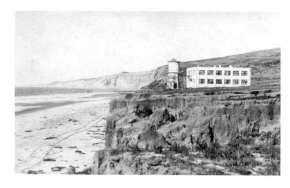

Left: George Scripps Laboratory, first structure at the Marine Biological Station, designed by Irving J. Gill. *Courtesy of the Online Archives of California, OAC.cdlib.org.*

Below: The Bishop's School and environs, with some of Gill's projects. *Courtesy of The Bishop's School.*

death, became the Museum of Art), Scripps Institution of Oceanography, the first St. James Chapel (1907–8) and the renovated Wisteria Cottage. Other projects designed by Mr. Gill included the original bathhouse at the Cove, the Kautz home (Bed and Breakfast Inn of La Jolla), the Cabrillo Hotel (1909), the Wheeler Bailey house on Princess Street, Windemere for John Kendall (1894) and more in San Diego, Coronado and Lakeside.

For Gill, the source of all architectural strength was the straight line, the arch, the cube and the circle. "In fact," he argued, "we should build our house simple, plain, and substantial as a boulder, then leave the ornamentation of it to Nature, who will tone it with lichens, chisel it with storms, make it

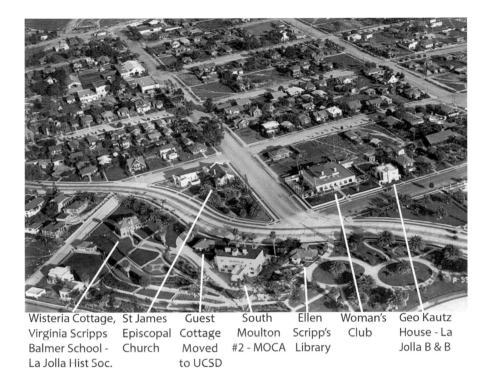

Wisteria Cottage, Virginia Scripps Balmer School - La Jolla Hist Soc.	St James Episcopal Church	Guest Cottage Moved to UCSD	South Moulton #2 - MOCA	Ellen Scripp's Library	Woman's Club	Geo Kautz House - La Jolla B & B

Aerial view, 1921. *From left to right*: Wisteria Cottage and Virginia Scripps Cottage (Balmer School, Cole's Book Shop and La Jolla Historical Society), St. James by-the-Sea Episcopal Church, Guest Cottage (Children's Art Center and was later moved to the area above Scripps Institution of Oceanography as the start for homes for UCSD professors), Ellen Browning Scripps Estate, South Moulton Villa II (MOCA), Ellen Scripps Library, La Jolla Woman's Club and George Kautz Home (Bed & Breakfast Inn of La Jolla) annotated to identify the Scripps Estate and Irving Gill's buildings. *Copyright San Diego History Center.*

gracious and friendly with vines and flower shadows as she does the stone in the meadow." Truly, he was a precursor of modernism. Although he died in 1936, he was rediscovered in the 1950s and '60s. In 1972, historian William Jordy wrote that "the unaffected manner in which the principle of simplicity brought Gill to the brink of the modern movement as this came to be defined in Europe…as well as the courage and foresight of an architect who literally invented his way in an isolated situation toward so much of what came to be the future."

The best example of Gill's work is probably the house he built for Ellen Scripps. Since her old house had been set on fire, her main concern was that the new residence be fireproof. The only vestiges remaining were the two cottages located on either side of the main house and a wooden pergola

in front. Gill's new design for the main house is considered by many as one of his masterworks. It featured a flat-roofed concrete structure with punched and ribbon windows and a large, arched entryway, leaving it relatively closed in front. Facing both the Recreation Center and the Woman's Club, both of which he had also designed, his design for the front of the residence allowed for privacy. The back of the house, on the contrary, was open, giving an unlimited view of the Pacific Ocean. There were wide porches and large windows. The inside had his usual sanitary features, including a concrete floor. To color the concrete floors, he could not find anyone who was, in his opinion, either competent or capable of doing the job. So, he, his nephew Louis and several of their draftsmen got down on their hands and knees on the rough, damp, unfinished floors and rubbed the color in themselves. It took several days to complete the job. Afterward, the floors were waxed to a soft sheen. Despite Miss Scripps's delight, others criticized the house, saying it looked like a "shoe factory." English artist and critic Maxwell Armfield considered it "one of the most successful efforts outside of Germany to solve the problem of modern reinforced concrete construction." David Gebhard, scholar of California architecture, may have the final word. Mr. Gebhard admired Mr. Gill's work but lamented the fact that he "was almost a prophet without honor in his own country....What happened to most of his buildings forms a sorry chapter in the history of the destruction of the usable past." Gill was a conservator of the past, building for the present. Fortunately, many of his projects remain in the present in La Jolla.

10

The Bishop's School

The Right Reverend Joseph Horsfall Johnson, bishop of the Episcopal Diocese of Los Angeles, established The Bishop's School in 1909. A graduate of Williams College, he valued higher education and wanted to ensure that students in his diocese had the opportunity to attend the best colleges and universities. He thought that the establishment of good preparatory schools was "the greatest contribution that the Diocese of Los Angeles could make."

Ellen Browning Scripps shared the bishop's belief in the importance of education. She had attended Knox College in Galesburg, Illinois, the only one of ten siblings to receive a college education. For a short period of time, she worked as a teacher, but with her brothers' rapidly expanding newspaper business in Detroit, she soon joined them and began as a copy editor and journalist at the *Detroit Evening News*. Later, she invested in her brothers' newspaper empire and donated most of her considerable wealth to charity. One "charity" she truly believed in was education. Together with her sister Eliza Virginia Scripps, she gave land and money to The Bishop's School. She told Mr. Harper, her lawyer, "I feel more than assured that I have embarked in an undertaking that is almost limitless in its scope and power for good."

Caroline Cummins became headmistress of The Bishop's School in 1921. She had graduated magna cum laude from Vassar College and received a master's degree in classics. This is her story in her own words:

CAROLINE S. CUMMINS

Miss Caroline Cummins. *Courtesy of The Bishop's School.*

The first time I ever heard of La Jolla was in the spring of 1918, when Miss Marguerite Barton reported to a group of her fellow teachers in Cambridge, Massachusetts, that she had had an interview with the Bishop of Los Angeles and had accepted the position of headmistress of The Bishop's School in La Jolla. She had a very inadequate little folder of the school with pictures of the building and seemed very excited about the whole thing. About two years after that, I was in Honolulu visiting my relatives. I had been there eight months when I had a cable from Miss Barton in La Jolla urging me to come over in the fall to help her out, as she didn't feel particularly well. I didn't know what I was to teach, I didn't know what my salary was but by that time I had decided that school work was my favorite pastime and so I gladly accepted and came over to California in September 1920.

The first contact I had with The Bishop's School was in the Santa Fe Railway Station in Los Angeles. I got to the station, as usual, early and had my bags clearly marked the way all Bishop's School girls were taught to do, and a lady who looked to me quite middle-aged came up to me and said, "I see you're going to The Bishop's School—teacher or pupil?"

When I said, "Teacher," she immediately said, "What are you going to teach?"

I didn't know because I hadn't been told, but I didn't dare say that I didn't know so I said, "I'm going to teach English."

And the lady said, "Well, that's my subject."

I backed down a trifle and said, "Just lower school English."

She happened to be Mrs. Helen Baker, an English woman who had taught English at The Bishop's School for a number of years. Later on, she became quite a friend of mine, but at the moment she didn't think very highly of me. On the train to San Diego, Mrs.

Morris and her daughter, Clidene, were traveling toward the school, and at San Diego she brought Mrs. Baker and me out to La Jolla. After having been eight months in the lush and lovely flowery atmosphere of the Hawaiian Islands, the country between San Diego and La Jolla looked to me very bleak and barren and brown and not awfully attractive. When I got to the school, the quadrangle of the school was still being converted from being a war garden. They were raising potatoes out there during the war so even that didn't look as it does at the present time. It looked bleak and a little dismal. The lovely palm trees in front of the school were just shrubs at that time, and of course, the grounds didn't have any vines and foliage because Miss Virginia Scripps, who was in charge of the planting at the institution, felt that trees were dirty and it mustn't happen. One of my early recollections of Miss Virginia was hearing her swear at Miss Sessions who was trying to put in some native California shrubs, and Miss Virginia didn't seem to think that any of them would be suitable.

The first year I was in La Jolla I lived outside the school in a cottage on Draper St, it was called MOUNTAIN VIEW. *Three other teachers and I lived in* MOUNTAIN VIEW—*the cottage was where the tennis court is now built, and later it was moved over across the street and Mrs. Crosby, who was Mr. Harper's secretary at that time, lived in it afterward.* MOUNTAIN VIEW *wasn't much of a cottage, but it was interesting to be away from the crowd for the first year.*

The first assignment I had in the school was to go to Del Mar with Trusty Shelton to meet two girls who were arriving from Denver and on that journey Mr. Shelton pointed out Nature's [scent] *and told me that the fragrance I was enjoying was sage and I learned a good deal about Nature on that little trip and began to appreciate this part of the country more than I did at first. As a matter of fact, it didn't take many weeks and many sunsets to know the beauty of La Jolla and appreciate the nice, invigorating air compared to the sultriness of the tropics.*

The people I met first in La Jolla were largely trustees and, of course, members of the faculty—it was all absolutely new to me—I hadn't been in California before. Miss Ellen Scripps was on the Board—Mr. Harper was on the Board—and Mr. Crandall and Miss Scripps was [sic] *particularly gracious to me although she was in her eighties and I was in my thirties, but she was a very kind trustee and impressed me very much because, although at meetings she seemed to be dozing, when the gentlemen on the Board were getting very much agitated about some weighty problem, she'd open her eyes and in a few brief sentences settle the whole dispute. In my early days, the school had its own cow stable, for instance, down on Sea Lane and Cuvier. The horse stable also was connected with the barn, and one of our first weighty problems in the Board meeting had to do with the cows when the zoning law made it impossible to have them. Miss Scripps worked that out and they were all sold, but until we sold those cows, we had milk brought to the school twice a day and during my first two vacations, we had so much cream that it was very bad for everybody.*

Miss Virginia was there only a short time during my reign. She left for Europe with the parting words to the girls that they were to keep La Jolla clean, and she died on that trip around the world and didn't come back again.

During my first year—in the middle of my first year—Miss Marguerite Barton died after an operation in a Los Angeles hospital. I had come to help her but I hadn't really come to stay because I had a contract with a school in New York City to which I was supposed to return. I was released from that. After the Bishop had gone east to find someone suitable and didn't feel that he found just what he wanted, he came back and urged me to stay at least one year to cover that period. I agreed to stay one year, and the time lengthened to thirty-three years.

La Jolla, when I came (1920), had 2,500 inhabitants. The streets weren't paved—one was, but not many were. It seems to me that the weather was different. We had more established rainy seasons, and I remember once going to the dentist, Dr. Post, on a rainy day and being greeted by him and his surprised wife with the statement that people in La Jolla didn't keep appointments when the weather was bad. But I had come from the East, and it never occurred to me that it wasn't a suitable day to go down there to have my teeth cleaned. Of course, the adobe soil had made the journey a little bit trying. A prolonged rainy season struck this part of the country one time, and the school, in the course of the storm ran out of butter; fortunately on the last day of the storm, Mr. Wheeler Bailey, whose business was in La Jolla but who was an interested trustee of the school, telephoned to ask if we needed any supplies....Mr. Bailey was a bachelor and knew very little about children and their appetites, but he loved the girls at the school and every year gave the seniors a party in his charming house on Princess Street. He always had a guest on that occasion if she was in town, Madame Heinrich [Anna Held]*....After Mr. Bailey's death, Mr. Hayden entertained the seniors in his beautiful house up on the hillside, and the girls never ceased to talk about the chocolate sauce which we had on ice cream on that occasion.*

The five decades which I have spent in La Jolla have brought tremendous changes, most of them inevitable—many of them very good. True—after Pearl Harbor, the increase of buildings, business, and people was appalling to those who had come to a small village. La Jolla residences then acquired numbers and the old names like Brodaer, Dalhusa, Ingle Nook, Tiny Tim, Geranium and others gradually disappeared.

Picnics on the dunes across the street had ended for The Bishop's School when the Scripps Hospital was built. Ice cream sodas at Putty's (located in the Colonial Hotel) and honey toast at Wind and Sea were all too soon replaced by Good Humors delivered to the back door of the school. Crown Point was no longer covered with wild flowers and the song of meadow larks was less often heard in open fields between La Jolla and Pacific Beach. When the western end of the canyon which had been so beautifully landscaped under the supervision of Mr. Roland Hayden was filled up to became a parking lot, the school ceased to be a country place on the edge of the town of La Jolla. I had just retired to the little house

which I was able to buy on Ravina St. next door to Mr. Ross Thiele's. Then and even now the street retains the spirit and feeling of old La Jolla. It is near enough to the cultural center for those of us who are less active to enjoy the cultural and artistic opportunities that are now available. For me, La Jolla proved to be an ideal spot in which to work and live.

Postscript

Caroline Cummins served The Bishop's School for thirty-three years. During her tenure, there were, on average, 125 day students and 75 boarders. She retired in 1953.

After retirement, she worked on the Social Service League, served on the board of the La Jolla Woman's Club, held the post of secretary of the Red Cross, took up the study of Braille to assist the blind and often would be found strolling through the grounds of The Bishop's School. When she began her time serving the school, there were only four buildings, a stable, horses and cows, and the original nine acres donated by Virginia Scripps had been increased by another two acres.

Cummins's tenure as headmistress began ten years after the founding of The Bishop's School. She saw and supervised many changes, but so many changes continue, with the school now being coed after merging with San Miguel School for Boys in 1971 and adding sixth grade to their classes. Nevertheless, despite all these changes, Bishop's still continues to stress moral and spiritual values. To that end, students attend chapel daily and participate in community service. During World War I, students rolled bandages for the Red Cross and raised vegetables and donated money for the military. Ellen Browning Scripps believed schools should be "an open door to knowledge" and educational methods should reflect the "experimental age" in which they lived. The Bishop's School remains committed to Scripps's educational ideals.

In 2008, Bishop's was ranked by the *Wall Street Journal* as one of the top forty schools in the country to send its graduates to select colleges and universities. Over one hundred years since its founding, Bishop's remains focused on fostering "integrity, imagination, moral responsibility, and commitment to serving the larger community."

All hail to you, dear Bishop's School,
your praise with you we sing.
Long may your spirit govern us,

and inspiration bring.
Simplicity, Serenity, Sincerity,
All three.
May we reflect these gracious gifts,
in constant loyalty.
Friendships we've made are ever dear;
Knowledge gained increases year by year;
Power to conquer, proved in work and play
carries us along life's way.
For perfect truth you've given us
and faith that cannot fail,
Our song proclaims our love for you,
all hail, Bishop's School, all hail!

Houses in La Jolla and the Revelle Residence

*M*any houses in La Jolla have curious and somewhat bizarre histories, but the one now housing the Bed & Breakfast Inn of La Jolla could have the wildest of all in terms of the odd variety of people who have been owners and lived there. Designed by renowned architect Irving Gill, the house was originally built for a former Kansas farmer and San Diego County lemon rancher named Charles Kautz.

Kautz lived there only briefly and sold the property to C.E. and Juana Kaltenbach, who opened the house at 7753 Draper Avenue to a singular string of renters. They included John Philip Sousa II, son of the famous march king, and Lady Imsay, wife of Lord Imsay, the British aristocrat associated with the sinking of the *Titanic*. Sousa, in a frenzy over ants inhabiting the ivy that covered the house, chopped the vine down; his attempt to pull it away from the house resulted in part of the structure coming down. Lady Imsay moved in with a flurry of British servants who went to the beach instead of maintaining the household. When she moved out, the house was left in shambles, and Juana Kaltenbach took over the property and ordered a redo by Armin Richter, one of La Jolla's pioneers in modern design. But by 1982, when Kaltenbach died at the age of ninety, the house again was falling apart. An heir suggested offering the Kaltenbach homestead "to the Moonies or some such religious sect, who could hobnob with the Presbyterians and Episcopalians as good neighbors should." (To the right of the house is the Presbyterian church; across the street to the left is the Episcopalian church.)

A few years later, an angel named Betty Albee came to the rescue. With the help of architect Tony Ciani, she renovated the landmark Gill structure, built an addition and opened it as the Bed & Breakfast Inn in 1985. The business continues today with rooms named in honor of some of the previous residents as well as Irving Gill, whose name honors the penthouse suite.

Gill designed the building in 1913 at the same time he was at work on the La Jolla Woman's Club next door. Relationships between the two structures are much in evidence, particularly in the way they are sited. The main entrance of Kautz's house is on the side instead of fronting the street, approached by a long walkway allowing the visitor to enjoy the Woman's Club gardens. Similarly, the club grounds look sideways into an enjoyable court belonging to the private residence. But architectural differences also exist between the two buildings. The Kautz house has pure, simple lines marking Gill's move into a more cubistic style. The club, with its vine-covered pergola and celebration of arches, throws back a bit more to European architectural traditions. "The arch is one of our most imposing, most picturesque and graceful architectural features. Its power of creating beauty is unquestionable," wrote Gill.

Today, both buildings are integral to the series of buildings from early La Jolla created through the collaborative efforts of philanthropist Ellen Browning Scripps with Gill as her architect. (See chapter 9.)

In 1915, Walter Scott Lieber developed "Prospect View." Over the years, Lieber constructed twenty vacation cottages, most with unencumbered views of the ocean, as all the surrounding lots at the time were vacant. His cottages were rented on a daily, weekly or monthly basis. Ultimately, all these cottages were demolished for newer housing except for one site named Redwood Hollow. Registered as a historic site, Redwood Hollow consists of eleven cottages and duplex homes in a random garden setting. In the tradition of old La Jolla, the cottages have names: Hidden Haven, Ocean Ridge, Sea Bright, Sea Gate, Beach Haven, Whispering Sands. Three are now private homes, but eight are vacation rentals. The architecture is Craftsman and Mountain style, popular in Southern California beach resorts in the early twentieth century. Per the business's website (http://www.redwoodhollow-lajolla.com), "This charming property is an oasis of peaceful greenery that still preserves the unique garden atmosphere of old La Jolla."

Driving down Torrey Pines Road, heading toward La Jolla Shores, on the left is a building (Historical Landmark No. 2440) that resembles a miniature Taj Mahal. This building was created by Herbert Palmer, an

English architect and grandson of Queen Victoria. His father, her son, became Edward VII. Palmer began construction on the landmark in 1927, and it took five years to complete. With its three domes, like the Taj Mahal, it was named Casa de las Joyas (House of the Jewels). There is a legend that there are jewels hidden in the house. Many other stories and legends abound, including one stating it was here that bootleggers hid during Prohibition. Originally, the house was to be the home for the president of a school of architecture, but the Depression came and ended that possibility.

When Barbara Cole came to La Jolla in 1946 with her husband, John, although there were already three bookshops, she opened her own. Prior to coming to La Jolla, Barbara and John had years of experience working at a bookstore, and they were originally going to open their own bookstore in Upstate New York. However, family and friends persuaded them to move to San Diego. It did not take long for them to fall in love with the climate and the seaside village of La Jolla.

Flyer announcing the opening of Cole's Book & Craft Shop. *Courtesy of Barbara Dawson Archives.*

Their original store was located on Ivanhoe and named John Cole's Book & Craft Shop. The crafts were items made by Barbara, who had planned to sit in the front window and weave to catch the eyes of passersby. But as the store became busy, Barbara gave up her crafts and focused on running the shop with her husband.

The store was "pure adobe out front," and John put up big flagstones. This store also had an attic for children's books. Barbara said they also had "wonderful owls." They had babies in the eucalyptus trees that were in front of her store as well as down the street. Local authors like Dr. Seuss (Ted Geisel) would come and read from their books for the children of La Jolla,

which in those days was a close-knit community. "You really knew everybody you saw on the street....If someone left their bicycle out, you'd just walk it over to the police department on Herschel and they'd take care of it," Barbara said. Henry Phillips of Adelaide Flowers agreed. "Business was seasonal—in the summer, people came out from Arizona, Texas, Oklahoma. There were big parties when the Del Mar races were on, and we were very busy. In September, all these folks cleared out, and it was quiet again until December, when people from the Midwest and East Coast visited."

In 1959, John Cole died of a heart attack, and Barbara took over managing the bookshop full time. Many skeptics did not believe a woman could run a successful business, recalled her daughter Susan Oliver. Eventually, Barbara Cole moved her bookstore to the Wisteria Cottage. With old furniture, folk art and fixtures, Barbara preserved the homey charm of the original site.

She instilled a love of literature in children and grandchildren and customers. In addition to dedication to her bookstore, Barbara Cole's love of La Jolla was expressed by her active participation in the La Jolla Historical Society (of which she was a charter member and corresponding secretary for many years),

Barbara Cole. *Courtesy of Barbara Dawson Archives.*

the San Diego Historical Society, the Wednesday Club and the arts, including the Athenaeum Music and Arts Library. Like Ellen Browning Scripps, Barbara Cole was conscious of and committed to her fellow man. "She felt it was important to help out other people," said her daughter.

Later, although no longer working full time at the shop, Barbara was helping with day-to-day operations, ordering books and answering questions from her many customers until the day before she died. Barbara Cole passed away in 2004, and La Jolla lost a very special lady.

Right: Wisteria Cottage showing the rock wall used throughout the Ellen Browning Scripps estate. *Personal collection.*

Below: Drawing of John Cole's Book Shop located in the Wisteria Cottage. *Personal collection.*

Many of the early La Jolla cottages had roofs over their porches supported by concrete pillars embedded with cobblestones gathered below the cliffs at Bird Rock (just south of La Jolla). Many of these houses also had low concrete walls containing cobblestones on their property lines. The cottage Barbara Cole moved her bookstore into, Wisteria Cottage (780 Prospect at the corner of Eads), is one example. Wisteria was originally built in 1904. In 1906, it was purchased by Virginia Scripps, half-sister of Ellen Browning Scripps. Virginia named it for the wisteria-covered pergola entry. In 1907, it was renovated by Irving Gill for Virginia Scripps as her home.

On January 11, 1906, the first meeting was held pertaining to the future of the Episcopalians in La Jolla. Through the generosity of Virginia Scripps, they were given the use of the Wisteria Cottage for all church purposes. On November 8, 1907, ground was broken for St. James by-the-Sea thanks to a lot given by Ellen Scripps. Virginia bought an adjoining house and lot, a space added later and used as a residence for the rector and as classrooms upstairs for the young parishioners.

On November 17, 1907, the cornerstone was laid for the St. James by-the-Sea Church. March 8, 1908, marked the day of dedication, at which service three children were baptized. This first church was designed by Irving Gill. Around 1915, it was sold to another congregation (now the Christian Fellowship). The tower that stood next to the 1907 church was built in honor of Ellen's Episcopalian half-sister Virginia. For this project, Ellen chose Louis Gill, the nephew of Irving J. Gill, as architect. He had come from Syracuse University to work for his uncle in 1911 and became his partner in 1914. In 1919, he set up his own business. The tower was designed as a replication of a tower Louis had seen in an old photograph. It was in this tower located near Mexico City at Camp Florida in which the forces against the Díaz regime had taken refuge. The *San Diego Union* noted, "In revenge for the heroic defense of the insurrectionists, the Díaz forces destroyed the church and tower with their heavy guns. Photographs of the church and tower were preserved, however." From March to September 1929, the tower stood next to the 1907 church. In September, the original church was picked up and moved to the corner of Genter and Draper Streets, but the tower remained.

While the new church was being constructed, the congregation met at the Woman's Club across the street. It was thanks to the growth of the congregation and the generosity of its members that the construction of a new and larger church was made possible. The new (and current) church was completed in 1929. To this day, the tower bells ring every quarter hour during daylight hours.

The Mission of St. James, designed by Irving Gill in 1907. The building was sold and moved to its present site at Genter and Draper to make way for the present St. James by-the-Sea. Lower image is the present La Jolla Christian Fellowship Chapel, originally the La Jolla Baptist Church at the time of the move. *Top, courtesy of St. James by-the-Sea Episcopal Church; bottom, personal collection.*

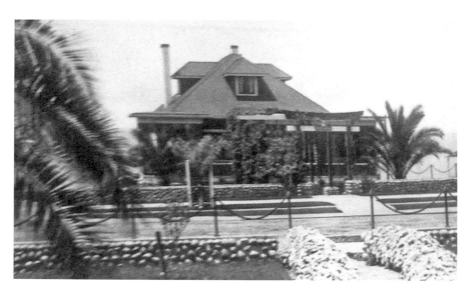

View of the Wisteria Cottage by Leopold Hugo taken from the front of St James, circa 1907–17. *Copyright La Jolla Historical Society.*

When Ellen Browning Scripps's original house, South Moulton Villa, built in 1897, burned down, she moved in with her sister at Wisteria Cottage while her new home was under construction.

After Virginia Scripps, and before Mrs. Cole made it her store, the Wisteria was the home of the Balmer School in the early 1940s.

After her husband died in 1919, Louise Congdon Balmer, a widow with four children, moved to La Jolla. Mrs. Balmer had graduated from Bryn Mawr College cum laude with majors in French and Latin. In 1924, she founded La Jolla's first nursery school in a cottage located behind her home at 921 Coast Boulevard. Her first class had four students. With teaching credentials obtained from studies at San Diego Normal School (now San Diego State University), Mrs. Balmer moved the school as it expanded to 939 Coast Boulevard. In 1941, Roger and Ellen Revelle, Miss Scripps's heir, provided a new site for the school at 780 Prospect Street, the Wisteria Cottage. From nursery to kindergarten through second grade, the author has very fond memories of her time there as a child, including sitting on the cobblestone wall painting pictures of the lovely wisteria vines growing over the entrance arcade. As Mrs. Balmer often said, "School should be life, not a preparation for life." We built birdhouses, studied the stars at night, danced in the front room to music from phonograph records and sang along to some of the tunes; in sum, at Balmer School, creativity was a key to learning. But keeping focus, paying attention, doing the proper homework,

Undated class picture of the Balmer School. *Courtesy of the* La Jolla Light.

Wisteria Cottage. *Courtesy of Eugene Ray.*

behaving—these, too, were Mrs. Balmer's requirements. I remember getting my mouth washed out with soap in first grade because I was talking (i.e., not paying attention) when class was in session. But the school was wonderful, especially

as it inspired the students to want to learn and learn more. In 1961, the school moved to its present location on the mesa east of La Jolla and changed its name to La Jolla Country Day School.

And the Wisteria Cottage? It is now the headquarters of the La Jolla Historical Society.

A cottage similar to the Wisteria Cottage is the Geranium Cottage, originally located on Prospect Street. Constructed in 1904, its architectural style is Craftsman-influenced vernacular-style bungalow cottage. According to the "Statement of Historical Significance," "The Geranium Cottage is architecturally significant as a rare local variant of a regional American housing style. While characteristic of a type of modest craftsman-built single family housing known as a 'bungalow cottage,' it is reportedly only one of two similar 1½ story side-gable bungalow cottages built in La Jolla." From 1906 to 1940, the cottage was inhabited by Dr. Edward Howard and his wife, Mrs. Eliza B. Howard. Dr. Howard was La Jolla's second physician, surgeon and deputy county health officer. When the doctor and his wife owned this cottage, it was located at 503 Prospect Street (around 1904 until 1914). However, the new La Jolla Recreation Center for the children and people of La Jolla was to be built, another gift to La Jolla by Ellen Browning Scripps. Because of its location, the Howards' house had to be moved. So the Howards had it picked up and relocated to Kline Street behind their new home at 7702 Fay Avenue, converting it into a rental property (one of two). Since then, many different businesses have moved into the cottage.

In 1998, the cottage was proclaimed a historical site. Kay Abbott and her daughter Kerry Wade had taken over and made the cottage into a tearoom serving light lunches and afternoon tea. It was their philosophy that while millions of us are rushing in our daily lives, most of us need to slow down a bit by savoring a cup of tea with family and friends. It was their thought that by preserving this little blue-and-white cottage, "one needs only to look right here for yesterday's more relaxing lifestyle." Today, it is the Public House Restaurant and has been painted red.

Many of the early houses, bungalows and cottages are now gone or, like the Red Rest and the Red Roost, which are covered with huge tarps as they decay, are soon to be places of the past. However, many still remain. Some were saved as business locations. Consider the new home of the La Jolla Historical Society in the Wisteria Cottage. But many are still being demolished.

Just before tearing down a home designed by the famous female architect Lilian Rice, I suggested to its new owner, Mitt Romney, that La

Geranium Cottage, 1904, now the Public House Restaurant, with historical plaque inset. *Personal collection.*

Jolla become independent of San Diego to preserve its integrity. "No," he replied. La Jolla could not preserve its legacy by becoming separate from San Diego. "Why?" I asked. "Because," he said, "La Jolla is the 'cash cow' for San Diego." Though sad, Mitt Romney's statement is true. San Diego owns La Jolla, unlike Del Mar and Coronado, which are independent and have preserved their integrity. And the Lilian Rice home? Very little remains, as it has been expanded into a mega mansion.

Meanwhile, next door to Governor Romney's house is—or was—Cliff Robertson's jewel, the historic Barber House. This is another example of La Jolla losing its integrity.

In 2002, the Barber House, also known as "Casa de la Paz," was designated as historic landmark No. 520. Cliff Robertson had purchased the house in 1963. He had such close ties with this property growing up and felt owning this house was a way to preserve the spirit of old La Jolla. Also designated as a historic landmark is the "Surf Shack" at WindanSea Beach. A little aside about WindanSea: When Cliff was fifteen, he used to catch lobsters off WindanSea Beach in a skiff built for him by Phillip Barber. It was during the Depression that Phillip Barber was forced to give up his home. How wonderful that his young fishing protégé would

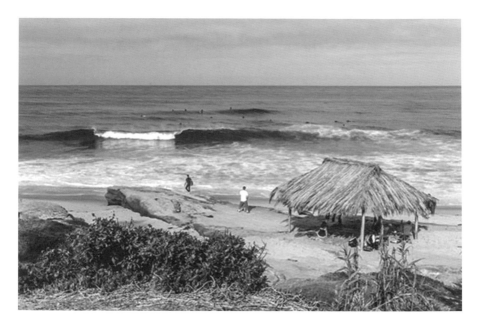

Surf Shack, WindanSea Beach, Historical Landmark No. 357. Palm shelter built in 1947 by surfers returning from World War II and the oldest continuously used shelter of its kind on West Coast. *Copyright Russel Ray Photos, russelrayphotos2.com.*

eventually purchase and preserve his home. However, sadly, this is not where the story ends.

Cliff once wrote, "I feel that my house represents not only the early Spanish architectural heritage, but it represents La Jolla in its once sleepy, warm, and friendly time. I hope these grounds will continue to be a reminder to all La Jollans what once was and what should be appreciated." The house, originally known as "The Dunes," was built in 1922 by Phillip Barber. This area, at the time, was an open, empty site of sand dunes descending into the sea. Later, the area, now including several homes, became known as the Barber Tract. After Barber was forced to sell his home in 1937, there were four owners before Cliff Robertson purchased it in 1963.

In the mid-1970s, Cliff hired Thomas Shepherd, a noted architect, to help restore and revitalize the residence, the gatehouse and the grounds. Cliff selected tiles from Mexico to adorn the façade and placed several fountains around the property.

Because La Jolla is now known for the cost of its houses sitting on parcels of land worth about $2 million an acre, many cottages from La Jolla's past are being torn down. However, at 7210 La Jolla Boulevard, part of the Barber Tract, sit three historic beach cottages. It is thanks to Pat

Three La Jolla historic cottages located between Arenas and Dunemere Drive on La Jolla Boulevard by Mr. and Mrs. Schaelchlin in an effort to preserve La Jolla's past. *Personal collection.*

Schaelchlin, La Jolla's late and beloved preservationist, that these historic homes are preserved. In 1974, Pat and her husband, Bob, bought an empty lot on La Jolla Boulevard as an investment. Instead of adding another new development to La Jolla, for the cost of loading them on flatbed trucks and moving them to their lot of land, they acquired and preserved three cottages. Thanks to Proposition 13, the compound's taxes on the relatively low price of the land could not be increased. The three cottages include the Yellow Cottage, a rare vernacular Victorian built in 1895. The Corey House is a 1905 hybrid of Victorian and Craftsman style; it is so named because of its first owner, the first female doctor in La Jolla, Dr. Martha Corey. The third, named Wall Street Apartments, is a 1918 Craftsman bungalow. Thus, instead of a mega mansion, thanks to the Schaelchlins, three pieces of the past have been preserved. The property is currently owned by people who believe the compound is a tribute to the original residents of La Jolla. "Here we are in 2006," wrote the new owner, Terry Jo Bichell, "in La Jolla living in the same houses where these people lived so long ago. Imagine a railroad executive, a newspaper man, and a pioneering female doctor sharing this courtyard. I wonder what they'd think of how things have changed."

The History of the Barber Tract

One of La Jolla's Oldest and Most Enchanting Neighborhoods
By Linda Marrone

The Barber Tract is a neighborhood rich in La Jolla history as well as a treasure-trove of early architecturally designed homes, many designed by master architects of the 1920s and '30s. In this picturesque neighborhood, bordered by white sand beaches, you will find homes with an eclectic mix of architectural styles, including Spanish Colonial, English Tudor and French Normandy, as well as quaint storybook cottages. Along the charming streets, vine-covered walls and gates hide secret gardens filled with mature landscaping and old-growth trees. The name the Barber Tract is what the neighborhood has been known ever since Phillip Barber began developing it in the 1920s, but it has never appeared in any legal description for the area.

NEPTUNIA: 1899 TO 1921

Before the Barber era, in 1899, Dr. J. Mills and Alma Boal purchased a large piece of land bordered by La Jolla Boulevard to the east (known as the "highway"), Westbourne to the south, Sea Lane to the north and the Pacific Ocean in the west. Planning to sell individual lots, they filed a subdivision map in 1902 and named the tract Neptunia. Development was slow, since most people felt the area was located too far away from the conveniences of La Jolla's central village. In 1914, A.G. Gassen purchased

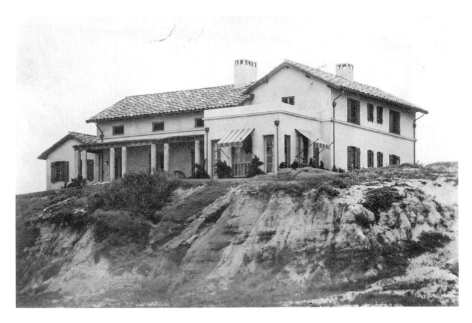

The Clark-Revelle home on Vista del Mar, Casa del Lido, was built in 1922. *Courtesy of Linda Marrone.*

land that comprised most of La Jolla's west side, which included the virtually undeveloped tract of Neptunia.

All homes will tell you stories about their owners and previous owners, but few homes can tell you the story of a family whose ownership spans over ninety years and is entrenched in La Jolla's early history.

A vacant oceanfront lot that we know today as 7348 Vista del Mar Avenue was purchased by Rex B. and Grace Scripps Clark in September 1920. In 1922, the Clarks constructed a home on the lot and named it "Casa del Lido" (House on the Beach). Fitch Haskell, a Pasadena-area architect the Clarks became familiar with when they lived there, was contracted to design the house. The builder was the Simpson Construction Company. The original home was designed in the Spanish Revival Eclectic style, and it was used as a summer home by the Clarks, who lived in Julian.

The Clarks purchased their lot just before developer Phillip Barber, the neighborhood's namesake, purchased the tract. In the early 1920s, the Barber Tract was a developing beach community with rugged sand dunes that cascaded down to a white sandy beach known as Whispering Sands. Mrs. Clark was told by friends that they should not move that far away from the village and would feel isolated out there. Even though it was considered to be out in the "boondocks," in 1920, Grace Scripps Clark and her husband,

Rex, purchased four oceanfront lots where Marine Street and Vista del Mar are today. Mrs. Clark was the niece of Ellen Browning Scripps and mother of Ellen, who would become the wife of world-renowned scientist and scholar Dr. Roger Revelle. In 1922, the Clarks built the Casa del Lido, using all four parcels, thus allowing for grounds and gardens as well as access to the white sands of Whispering Sands Beach. Casa del Lido passed to the Revelles in the 1930s and remained in their family until 2012.

Phillip Barber finished his oceanfront Spanish Colonial residence, The Dunes, in 1923, just after Casa del Lido was completed.

The Clarks divorced in 1932, and Grace married her second husband, Johan G. Johanson. The Johansons built a Colonial Revival–style home at 1540 Virginia Way in 1937. This home was designed by architect William Field Staunton Jr. and is now historically designated as the Grace Scripps Johanson House, HRB site No. 431.

In 1940, the home at 7348 Vista del Mar Avenue was deeded to Grace's daughter, Ellen Clark Revelle, and her husband, Dr. Roger R. Revelle. The Revelles took up permanent residence in the home in 1947.

The Revelles raised four children at the Vista del Mar home. During their ownership, the original home's footprint was expanded to accommodate their growing family and the home's architectural style was changed from Spanish to a more minimal traditional that was very popular in the 1940s through the early 1960s. The original garage with chauffeur's quarters still maintains its Spanish style and red tile roof and is now the guesthouse.

Today, the home is approximately 4,165 square feet, with five bedrooms and four bathrooms. The guesthouse has a large living area with ocean views and a bedroom and bath above the two-car garage. The oceanfront lot is over 18,000 square feet, with approximately 115 feet of sandy beach frontage. The entrance to the home is through a lush garden/pool area. Gardens also border the north side of the home and were used as Mrs. Revelle's cutting gardens. The backyard offers a deck and lawns that overlook the Pacific Ocean and the white sands of Whispering Sands Beach.

THE BARBER ERA: 1921–1930s

While on vacation in La Jolla in 1921, Phillip Barber purchased twelve acres of what was once part of the Neptunia subdivision from the estate of the late Mr. Gassen for $22,875. Barber was an heir to the Barber & Company

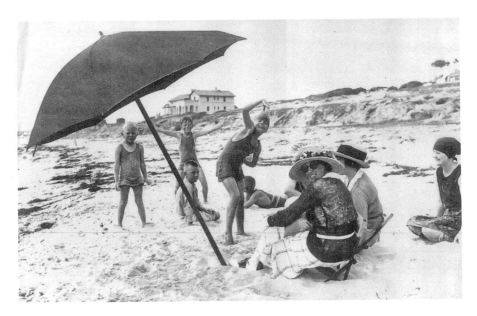

The Phillip Barber family on the beach in front of their home. The residence in the background is the Casa del Lido (Clark-Revelle home), 1920s. *Courtesy of Linda Marrone.*

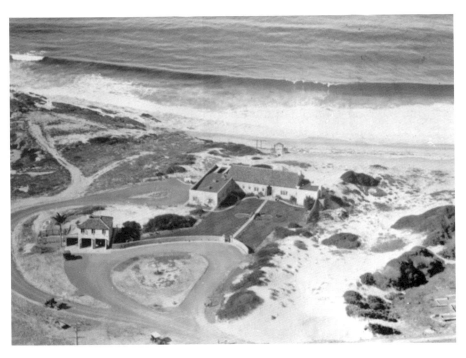

Aerial view of Casa de la Paz (the Dunes), the home built by Philip Barber, 1922. Purchased by Cliff Robertson in 1963. *Copyright Jeffery Barber, www.wags.org.au.*

steamship firm in New York. The sixteenth of eighteen children, he was a visionary and dreamer with an artistic sense who, in many ways, was a man ahead of his time. The rugged sand dunes that ran throughout the area he purchased reminded Barber of a favorite vacation spot he frequented on Long Island, New York, and as soon as he saw the property, it was love at first sight. Barber's daughter Barbara Barber Stockton, who passed away in March 2009, recalled her very excited father telephoning her mother, Mary, in Tenafly, New Jersey, saying, "Pack up the family; I've just purchased property in La Jolla, California!"

The Barber family moved to La Jolla in 1921, and in January 1922, architect J.H. Nicholson pulled a building permit for the Barber family residence that would be located on a large oceanfront lot on Dunemere Drive. The permit was on behalf of Phillip Barber, the owner and "designer" of the residence, and the estimated cost for construction was $3,000. Although Barber hired architect Nicholson, his daughter Barbara said that her father had a passion for woodworking, architecture and construction, and she believes he was responsible for much of the design concept and construction that went into the stately home.

In the fall of 1922, just after Casa del Lido was built up the beach, Barber finished construction and moved his wife and four children (a fifth child, daughter Tootie, was born later) into their sprawling six-thousand-square-foot, six-bedroom, five-bathroom Spanish Colonial–style home he aptly named The Dunes. In addition to the main house, there was a gatehouse that included a garage plus a one-bedroom, one-bath apartment for the chauffeur. The home was built on steel pilings, and its size was considered "daring" for the day. Phillip Barber served on the architectural committee for the *National Better Homes* publication. In October 1922, his home was featured on the Better Homes Tour and open to the public.

On January 15, 1922, the *San Diego Union Tribune* reported that Barber intended to open a tract surrounding his new home, "[w]herein only the most costly homes may be built." Soon after, development took off, with architect-designed homes appearing all around the neighborhood, many designed in the European Revival style that was gaining popularity across the country during this era. Barber considered La Jolla "America's Riviera," and this style of architecture fit in perfectly with his dream to have the neighborhood feel as though it were a seaside village in Europe. Early noteworthy San Diego architects, such as Edgar V. Ullrich, Tom Shepherd, Herbert Mann, Herbert Palmer, Richard Requa, Lilian Rice and Florence Palmer, all left their eclectic architectural imprint on this seaside terrain.

The Barber family. *From left to right*: Robert Barber, Mary Ann B. Hatch, Mary P. Barber, Philip Barber, William H. Barber and Barbara B. Stockton. *Courtesy of Linda Marrone.*

Barber designed several homes in the neighborhood himself and experimented with adobe. He hired Native American workers to assist him with the design and construction of these adobe homes. Two other homes Barber designed and built were the "Blue House" on Dunemere Drive and the "Pink House" at the corner of Olivetas and Sea Lane. Barber built the Blue House in 1923 to use as a guesthouse and designed it in an Egyptian style he was experimenting with. The home was purchased in 1931 by Marie Biggar, who hired architect Herbert Mann to expand and redesign the home into the Pueblo Revival style, the style it conveys today. The Blue House is now Historic Site No. 812, the Marie Biggar/Herbert J. Mann House.

THE GREAT DEPRESSION ERA: 1930–1940

The Great Depression of the 1930s slowed development of the Barber Tract for a number of years. Many of the homes were left vacant. Even Phillip Barber had to relinquish his beloved home and properties to creditors during this difficult time. Barber remained in La Jolla until 1946, then moved to the Julian area. He passed away in 1963 and his wife, Mary, in 1965.

During the 1930s, a few homes were built, including our home and guesthouse at 7150–48 Monte Vista Avenue, designed by master architect Edgar Ullrich in 1935 and constructed by builder Charles Larkins as his own residence. Larkins owned several lots nearby, where he built homes for family members. He also built many homes throughout the neighborhood for clients, including a home for Phillip Barber's daughter Barbara on Westbourne Street that still stands today. The homes built during the Depression displayed a more minimal, traditional style of architecture, without a lot of embellishments.

WORLD WAR II AND POSTWAR: 1940–1950s

In the late 1940s, development began again with the subdivision of lots on the cul-de-sac of Vista de la Playa, including sand dunes that were once part of the Barber estate, The Dunes. During this era, homes with a more modern approach were constructed including designs by master architects Russell Forester and Lock Crane.

1960s–PRESENT

The home Barber built on Dunemere Drive remains today but has undergone many changes since the Barber era, most of which have taken place in recent years. In 1963, La Jolla native and Academy Award–winning actor Cliff Robertson purchased the Barber home, which was in a state of neglect. Robertson had been friends with Phillip Barber and his children while growing up in La Jolla, and he remained close to Barber's daughter Tootie Barber Hatch throughout his life.

Robertson hired master architect Thomas Shepherd in the mid-1970s to make a few sensitive modifications to the property. Trees were planted along with expansive lawn areas replacing the barren sand dunes. Robertson was told grass would not grow so close to the beach because of the salty sea air and sandy soil, but to everyone's surprise, it thrived, as have many of the trees that have now grown to towering heights. Robertson fought the California Coastal Commission for almost seven years to build a seawall to keep his property from eroding. He placed a plaque on the seawall that remains to this day commemorating the contentious battle he fought to have the wall built.

In 2002, Robertson had his home and its original gatehouse historically designated as Casa de la Paz/The Dunes, Historic Site No. 520. The name is a combination of Robertson's name for the home, Casa de la Paz (House of Peace), and Phillip Barber's, The Dunes. When Cliff Robertson contacted me about historically designating his home, he said he wanted to ensure it would not be torn down in the future since the lot measured almost an acre and a half and could have been subdivided to accommodate more than one home. After its designation, Robertson sold the estate in 2005. In 2008, the home sold again to the present owners, who have substantially remodeled and expanded it with surprising permission from the City of San Diego's Historical Resources Board. While the front façade resembles much of its original form, a large addition to the rear of the home now takes over much of the land where lawns once dominated. Cliff Robertson passed away 2011, and I always wondered if he would approve of the changes that have been made to the home. Recently, I was contacted by a grandson of Phillip Barber, who told me he felt his grandfather would have wholeheartedly approved of the changes that have been made.

After purchasing our home in 1987, we found Edgar Ullrich's architectural drawings and plans in a closet and decided to historically designate our home, which was not common at that time. We hired the late Dr. Ray Brandes to research our home's history, and during this time, we were also fortunate to meet Marion Ullrich, the daughter-in-law of architect Edgar V. Ullrich, as well as Barbara Barber Stockton and Tootie Barber Hatch, Phillip Barber's daughters. I walked through the neighborhood in 2000 with Barbara Stockton, and she shared many stories of her family and the old Barber Tract with me and showed me where she played as a child. With the help of all these people, including Cliff Robertson, we were able to learn more about the history of our home, Phillip Barber and

our beloved neighborhood. Our home was historically designated as the Morgan-Larkins-Marrone Residence, Historic Site No. 226 in 1989.

The Barber Tract remains one of the few La Jolla neighborhoods where much of the original style and ambiance still exists. Today, the neighborhood boasts twenty-one historically designated homes, more than any other La Jolla neighborhood. All of these homes have been voluntarily designated by their owners in an effort to maintain the allure and charm that compelled all of us to make this seaside neighborhood our home.

The Story of La Jolla by the Sea

Election Year

*I*t is election year. The nation "awaits in partial paralysis" as the new presidential campaign elicits the concerns of a nation at peace despite an undercurrent of nagging unease. The feat of La Jolla is to produce "a thousand dollars worth of building permits for each of its four thousand inhabitants or a total of four million dollars worth of construction in all, may be unprecedented." This is the year that "La Jolla proportionally outgrew even San Diego."

What year is this?

"Despite distinctive La Jolla being notable for its complete absence of ordinary resort attractions, factories, trains and crowds, while still preserving intimate touch with the best of outside life, one of the coast town's many features is the new fast interurban electric service between La Jolla and San Diego. The most modern and elaborate cars in America operate on this high-speed line, and so put La Jolla within thirty minutes of San Diego by train, as it is by stage and motor."

What a great idea! The transportation seems so much better than the "throat" congestion we know today. Obviously, it couldn't be the year 2016.

"Understand, however, that while La Jolla is an integral part of the City of San Diego, and shares in all civic advantages, it is a distinct community, complete in itself, with its own schools, its library, its art centre, churches, clubs, scientific groups, and public gatherings."

Does San Diego City government understand that La Jolla "is a distinct community"?

"In La Jolla, there is no necessity for shade trees nor porches, because here, of all places one wishes to be, [always] in the beneficent sunshine where, rejuvenated by its powerful chemistry, one grows to that green old age which has made death in La Jolla so rare and anomalous. People in the old age of their youth and people in the youth of their old age come to La Jolla and wonder why they remain young."

No, it could not be year 2016 if they didn't need sunscreen. But it is nice to know that the air was once pure and the sun "beneficent"!

"In this magic land of perpetual sunshine and growth, nothing dies. Flowers bloom year-round, never stop blooming. There is no fall or winter to suggest a passing. There is only spring and summer, and spring is summer and summer is spring."

"A magic land" it is. So, who are the people who live in La Jolla, what are they like?

"La Jolla is unique in the simplicity and informality of its living conditions, despite the town having a disproportionately large number of names in 'Who's Who'…names of famous authors, scientists, painters, musicians, sculptors, world travelers, lecturers, famous women and others."

The list grants women their own separate category. It could not have been written in the year 2016!

CORRECTING a little mistake made in the summer of 1928.

Political cartoon. *Public domain.*

"Being cosmopolitan, La Jolla is simple and unconventional. People have gathered from too many places to erect a rigid social structure. They know too much of life to be narrow either in belief or custom."

Sounds too good to be true. What year is this?

In La Jolla, "wealth is never obtrusive and moderate means never a disadvantage. Here, economy is always possible through common-sense style of living in vogue, the absence of extravagant standards of dress, housing and entertainment."

Definitely not the year 2016.

"Always, over all La Jolla, the quiet of simplicity, the hush of beauty—the ideal place for youth, age and mental work. This serenity of Nature it is which makes La Jollans so simple and unaffected, which renders them oblivious to the artificialities of life."

No, it doesn't sound right for the year 2016.

"As there is a whole literature of escape, so is 'La Jolla, Sunset Land' increasingly the escape of prominent persons from their prominence; an escape to the 'Sunlit Place of Heart's Desire,' where they may return to the bright solace of simple, anonymous living; to blue sky, brown mountain slopes and serene sea forever."

Sadly, not "forever."

We present these sentiments for you to ponder. Have you discovered the year yet?

The Story of La Jolla California: Where Blue Meets Gold in Endless Splendor was issued to tourists by James A. Wilson, proprietor of the Cabrillo Hotel in La Jolla. The year? 1924. (The Cabrillo Hotel is now incorporated into the west wing of the La Valencia Hotel on Prospect Street.)

14

La Jolla Had Its Own Railroad

When the tracks of the old La Jolla Railroad line were picked up and sold to Japan for scrap in 1918, La Jolla was left without public transportation to San Diego. La Jollans petitioned the San Diego City Council to provide La Jolla with a streetcar line, and the council negotiated a franchise with John D. Spreckels to extend his Mission Beach line, which was then under construction, to La Jolla. The extension to La Jolla utilized part of the old abandoned railroad right of way of the San Diego, Old Town & Pacific Beach Railway. The route came north on Mission Boulevard, where it joined the old railway right of way in Pacific Beach, continued up La Jolla Hermosa Boulevard, named Electric Avenue at the time, and then passed through Birdrock to the south end of the present-day bicycle path. From there, it left the old railroad right of way and traversed the path emerging at the corner of Nautilus Street and Fay Avenue by the high school. The tracks continued down the length of Fay Avenue to Prospect Street, where they circled an elaborate terminal building.

Not all La Jollans were enchanted with the arrival of a rapid transit system that would place them only forty-five minutes from that metropolis to the south or to be connected so closely with hoi polloi of Mission Beach. Many would have wished to keep their privacy and enjoy their isolation rather than put up with the expected "invasion" of outsiders. When the streetcars made their inaugural runs down Fay Avenue on July 4, 1924, residents were said to have shuttered their windows and gone into seclusion. The invasion came in flood proportions, particularly on summer

weekends when the line ran four-car trains to handle the large numbers of day-trippers from San Diego, depositing thousands of fun seekers into the village to overrun the quiet streets and beaches. This made for heavy demands on limited resources and entertainment facilities. La Jollans' bucolic atmosphere was shattered forever. Nothing changes a community faster than advances in transportation.

Photos over a century old show groups of people on the sand and rocky shoreline gathered around picnic hampers. Ladies are wearing ankle-length gowns with long sleeves and big hats. The men are in dark suits, ties and bowler hats. Other than a few hardy cyclists similarly attired, the main activity seemed to be an occasional shallow dip, gazing out to sea and collecting sea grasses for pressing in family albums. These folks arrived by horse-drawn tally ho carriages, buggies and the Pacific Beach–La Jolla Railroad. To increase ridership, the railroad provided attractions in La Jolla such as balloon ascensions, daredevil dives from cliffs, circus acts and a pavilion for social activities.

A quarter of a century later, the streetcars not only brought holiday visitors but also regular commuters who worked in La Jolla and lived elsewhere or visa versa. Two opulent structures were built to serve the riders of the La Jolla No. 16 streetcar line. These included a terminal at the corner of Fay Avenue and Prospect Street and a station in the Hermosa area one block to the east of La Jolla Boulevard. Both buildings were erected in the Spanish Colonial architectural style similar to the buildings in Balboa Park and the military bases of Midway and Point Loma. The conveniences and amenities of each building were beautifully executed. They were more than adequate to meet expected passengers' needs. It is puzzling why a couple of streetcar stops were built to simulate the grandeur of large metropolitan railroad stations. Neither building was ever fully utilized. In fact, both were partially abandoned during most of the operational life of the No. 16 car line.

The terminal building that stood on the southeast corner of Fay and Prospect Street was a round structure, which allowed the tracks to circle the building. Coming north on Fay, the tracks turned right on Prospect and completed a circle around the building to exit on Fay again. Passengers could board the cars directly from the lobby on the south side of the building. Only one photograph was ever made of the interior. Fortunately, it was taken by a professional photographer, and the quality image captures details quite clearly. The circular wall appears to be finished in cut stone. A large skylight in the roof, coupled with indirect lighting fixtures supported by decorative corbels spaced around the wall, furnished the interior lighting.

Driving the Golden Spike, San Diego–La Jolla Railroad, 1894. *Copyright San Diego History Center.*

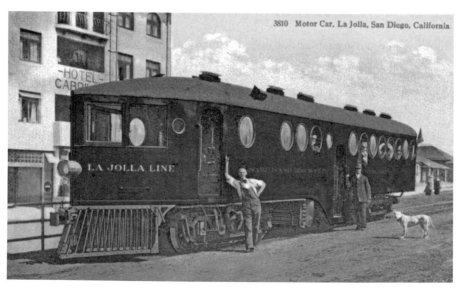

McKeen Motor Car of the San Diego–La Jolla Railway Line in front of the Cabrillo Hotel on Prospect at Herschel. It was painted red and known as the "Red Devil." By this time, the Silverado-Ivanhoe loop had been completed. *Courtesy of the McKeen Motor Car Company Historical Society.*

In the center stood a fountain surrounded by planters containing palms and exotic plantings. The floor appears to have been paved with Mexican tile. "No expense was spared in its construction. This is readily seen on entering the spacious circular lobby or waiting room with glass dome in the center directly over the fountain. Tiled floors, plate glass on all sides, and also in the doors. The finest of gum brush, and copper glass bead. Hardly a flaw is to be found after almost 16 years of service." This was a news item in 1940 when it was announced the terminal was to be demolished. Passengers must have enjoyed waiting for cars in this ornate setting. However, this is what one rider-historian had to say:

> *At Prospect and Fay was an elaborate doughnut shaped building. The terminal was encircled by tracks which ran around the building to turn the trolley around. Inside the terminal were spaces for a number of small boutique type shops, usually vacant. The terminal did furnish shelter on rainy days, but always seemed a dank, cold, gloomy place. Cars left only twice an hour, and no one waited at the terminal longer than could be helped. It was too deserted and spooky. In the last years of No. 16, cars no longer turned around the circle. Motormen reversed the trolley instead. Parts of the circular track were removed even before the line was abandoned in 1940.*

It was too much trouble to take the car around sharp curves of the circling tracks. Since passengers didn't use the terminal anyway, it was much easier to stop the cars at the dead end of Fay Avenue and reverse the trolley, a procedure common for all streetcars. (The demolished building was dumped over the beach-side bluff just north of Marine Street, where the White Sands is now located.)

The station off La Jolla Boulevard in the Hermosa area was known as the San Carlos Streetcar Station. Unlike the terminal, it survived depression, war and time. Today it is an architectural gem in the attractive compound of the La Jolla Methodist Church. The building houses a chapel and a youth lounge. In previous times, it was utilized as a school of arts and crafts, a dancing school, a restaurant and a synagogue. During World War II, defense industries used it as a school to train defense workers. Like the terminal, it was never fully utilized because it was built in an isolated area. Conductors rarely stopped the cars at the station because few passengers got on or off at the stop. This remote location may have been dictated for technical reasons. The primary purpose for the building was its function as a substation. It housed electrical transformers

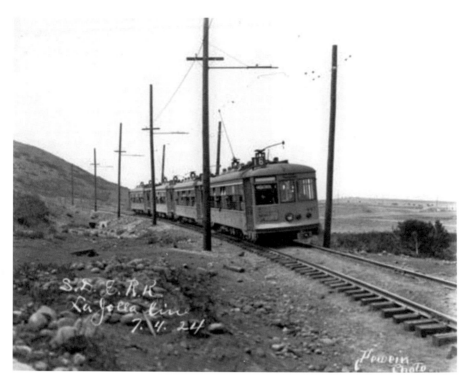

Above: San Diego Electric Railway streetcar approaching Nautilus Street, 1924. *Copyright San Diego History Center.*

Left: The San Carlos Electric Railroad Station of the La Jolla and San Diego Electric Line, 1924. *Copyright San Diego Historical Society.*

that boosted power line voltage so the cars could reach the end of the line. Most streetcar substations were rather plain structures.

On the southbound run from La Jolla, the nickel fare increased to a dime at the station. To avoid paying the extra fare, high school students who lived a few blocks farther south in Bird Rock would get off the trolley at the station. On occasion, when approaching from the north, if no one was seen waiting on the platform, the conductor would accelerate the car and pass the station at a high rate of speed. When the car passed the station, he would cut the power and coast down the tracks to a stop closer to the students' homes. Apparently, the logic of this altruistic action was if no power was used beyond the station, it didn't cost the company anything. In the morning, students, who always seemed to be late, raced along the tracks up to the trolley station and the five-cent fare. The conductor would reduce speed and stop at the station although no passengers were waiting. On the morning northbound run, the company made up for a few nickels it didn't collect on the afternoon southbound run.

Japanese truck farms occupied the area north of Turquoise Street and where Bird Rock Elementary School is today. Commuters called this area the Japanese strawberry patch. During the strawberry season, growers would set up a table alongside the tracks with baskets of strawberries and a coffee can on which was written the price of the berries. The conductor would stop the car, and those who wished got off to buy baskets of strawberries. Of course, it was understood, as a courtesy for this service, the conductor got to choose the biggest and juiciest strawberry from each basket.

University of California Comes to La Jolla

*W*hen plans were in process for the University of California to have a campus in La Jolla, the site chosen of this new institution was Camp Matthews. Up to World War II, the camp had no name and was known simply as the Marine Rifle Range, La Jolla, and was under the command of Marine Corps Base, San Diego. On March 23, 1942, the camp was officially named Camp Matthews in honor of Lieutenant Colonel Calvin B. Matthews, USMC, a distinguished marine marksman in the 1930s. The lieutenant colonel later became a brigadier general. Initially, the camp accommodated some seven hundred men. However, following Pearl Harbor, the enlistment was over five thousand marines. There was not enough room. At the peak of the war, as many as nine thousand men, including marine aviation units as well as army and navy units, were rushed through the rifle range every three weeks.

Camp Matthews continued to function during the Korean War. However, by 1963, it became clear this was a dangerous hazard to civilians, since neighborhoods in La Jolla were expanding eastward and the relatively new subdivision established by Carlos Tavares and Lou Burgner named after Carlos's wife, Claire, Clairemont, was growing rapidly, expanding northward on the mesa east of the Pacific Coast Highway (now I-5) toward the rifle range. (There was also a huge parakeet farm located just to the east of the camp along the original Miramar Road.) In 1964, Camp Matthews closed. The marines' weapon training was moved farther north to Camp Pendleton. Hence, the area was now available and, to some, a perfect site

for a new campus for the University of California. However, there was some hesitation. Many La Jollans would need to lay aside old prejudices in order to welcome a culturally, ethnically and religiously diverse professoriate into their midst.

Following World War II, La Jolla had a history of restrictive housing policies, often specified in deeds and ownership documents. For the purchase of homes in La Jolla, only people with "pure" European ancestry could own property. Thus, Jews were excluded. Such "restrictive covenants" were once fairly common throughout the United States. It wasn't until 1948 and the ruling of the Supreme Court (*Shelley v. Kraemer*) that such rules became unenforceable. Twenty years later, Congress outlawed them in the Fair Housing Act (Title VII of the Civil Rights Act of 1968). However, realtors and property owners in La Jolla continued to use subtler ways of preventing or discouraging Jews from owning property. Roger Revelle stated the issue bluntly: "You can't have a university without having Jewish professors. The Real Estate Broker's Association and their supporters in La Jolla had to make up their minds whether they wanted a university or an anti-Semitic covenant. You couldn't have both."

Roger Revelle had already experienced this trauma. A few years before, he had created a neighborhood designated for the Jewish scientists who came to work at Scripps Institution of Oceanography and could not purchase homes in La Jolla. Revelle had the little guest cottage located in front of his wife's aunt Ellen Browning Scripps's house in La Jolla, the cottage in which his wife was born, moved to become the first house in a new neighborhood for Jewish families. It was relocated just above Scripps pier. So when there were issues regarding the establishment of a branch of the University of California in La Jolla, Roger Revelle was ready to fight for this right.

We should note that just next to Camp Matthews was Camp Callan. Built in the 1940s, this post ended up with over 297 buildings, 3 theaters and 5 chapels. During its tenure, over fifteen thousand men received a thirteen-week training course there. Camp Callen was a Coast Artillery Corps with an emphasis on modern artillery and antiaircraft defense weapons. According to Howard S.F. Randolph in his 1975 book, *La Jolla Year by Year*:

> *With ominous war clouds all around us, Uncle Sam erected Camp Callan, three and a half miles north of La Jolla. It extended from La Jolla Junction on U S Highway 101 to the sea, and northward for almost three miles* [toward the Torrey Pines Reserve]. *It was named for Major General Robert A. Callan. The Camp was opened on January 15, 1941,*

The Children's Art Center, formerly the guesthouse on the grounds of Scripps estate, South Moulton Villa. The house was later moved to the area near UCSD to provide professorial housing. *Copyright La Jolla History Society.*

and the first trainees arrived on March 6th. With the advent of the Camp, La Jolla took on a military appearance, much as it did in the first World War. Soldiers soon crowded our streets, and it became immediately apparent that a club house of some kind was necessary. This was supplied by the U.S.O. (United Service Organizations) in a former store at 1015 Prospect Street, which was placed under the management of Mr. Fred Schutte. This was opened on August 31, 1941. With Pearl Harbor on December 7th, war came in earnest, and a much larger U.S.O. building was opened on January 3, 1942, at the corner of Eads and Silverado. [This became St. James's Hall owned by St. James by-the-Sea Episcopal Church.]

After World War II, the camp was decommissioned, leaving only roads and foundations. Many of La Jolla residents' children, including the author, learned to drive in this deserted area. Subsequently, a Sports Car Club of America (SCCA) race course was established on some of those roads. However, it was not until the university was built and needed to expand that

any of the Camp Callan site would harbor a section of the UCSD campus. Today, the area includes the historically significant glider port, the Torrey Pines golf course, several private businesses and research facilities, including the Salk Institute.

Returning to the development of a new campus for the University of California, it was decided that because of the controversies and complaints of many La Jollans, the name would not be University of California–La Jolla. Instead, it would become the University of California–San Diego. By 1960, a graduate division of the school had already opened. This division comprised courses in science, which were held in the Scripps Institution of Oceanography located on the oceanfront in the area of La Jolla known as La Jolla Shores.

(Apropos La Jolla Shores, in the early 1920s, R.C. Rose, a gentleman who had come to La Jolla from Germantown, Pennsylvania, with his young family, started a spectacular real estate development. A man of vision, he bought land that would become La Jolla Shores, had it surveyed and then planned a big, colorful land sale. Although many lots were sold, it was ten years before much building occurred.)

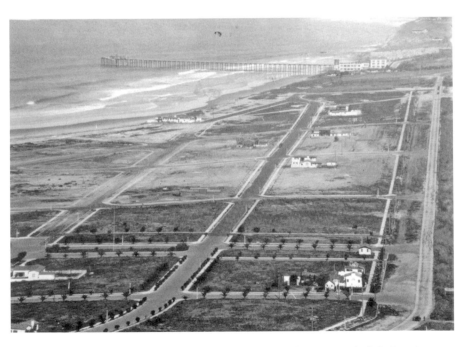

La Jolla Shores Subdivision, circa 1929. The Spanish-style houses were built before the Depression. Compared to the following picture, very few homes were built there until after World War II. *Copyright San Diego Historical Society.*

La Jolla coastline, including the empty La Jolla Shores Subdivision during World War II. The aircraft is a PBY2 Coronado flying boat manufactured by Consolidated Aircraft. *Personal collection.*

Long before moving to the shores, Scripps Institution of Oceanography's history goes back to 1903, when members of the Scripps family and other community leaders chartered the Marine Biological Association of San Diego. How did this connection occur between science and the Scripps family?

When Dr. William Ritter came down to San Diego from the University of California–Berkeley to begin his oceanographic studies, he opened a small, temporary laboratory in the boathouse of the Hotel del Coronado. Dr. Ritter was a University of California professor of zoology. In 1905, E.W. Scripps and other members of his family paid a visit to Ritter's marine laboratory. As he looked around the tables of the laboratory and the specimens collected, E.W. Scripps said, "We aren't too old to learn a good deal about biology, and I tell you it is mighty interesting." So after two summers in Coronado, Professor Ritter traveled up the coast to La Jolla, a place he described "in most ways unsurpassed in natural charms by any other on the California coast." With funds supplied by the Scripps family, the first La Jolla facility was built above the La Jolla Cove. It was known as the "Little Green Lab." However, it soon became clear that because of the expansion and development of the village of La Jolla, the location above

the Cove was unsuitable. When a 177-acre seaside parcel was purchased for $1,000 by the Marine Biological Association at an auction (although it was Ellen Scripps who ultimately signed the check and paid for the purchase), a gradual move was made to the new location. This occurred between 1907 and 1910. This parcel had once been part of San Diego's Pueblo land, and it was a coastal area that included a wide variety of habitats such as kelp beds, sandy beaches and rocky reefs. These were natural laboratories and great for scientific studies and collecting. The upland area was going to be perfect for a future campus expansion.

This new property was at the most northern end of La Jolla Shores. The Scripps laboratory being constructed consisted of one building. Designed by Irving J. Gill, it was Gill's philosophy to "let nature supply the contrast." And it should be noted that Dr. William Ritter, Scripps's first director, like Irving Gill, was inspired by nature. Dr. Ritter stated that he was convinced "of both the fundamental unity and the fundamental diversity of all nature… that the whole of nature is a system." It was this belief that helped mold Ritter's vision of the oceanographic institution that was to become Scripps.

Completed in 1909, the building was originally dedicated as the George H. Scripps Memorial Marine Biological Laboratory in honor of Ellen Browning Scripps's late brother, newspaperman George, because of his interest in science. It is the oldest oceanographic research building in continuous use in the United States. The original cost was $15,816.09. In 1910, the public aquarium (recommended to Scripps by her brother E.W. Scripps) was located on the first floor in the southwest corner. Although the lecture hall and museum were to be located on the second floor, Dr. William E. Ritter and his wife, Dr. Mary Bennett Ritter (teacher, physician and woman's rights advocate), moved into the second floor awaiting the construction of their own home. According to Mrs. Ritter, their temporary "home" on the second floor was "the most difficult room to furnish and decorate." She had to devise a canvas awning to cover the skylight. It was three years (1913) before they could relocate to a "real" home, the Director's House.

In 1912, the marine lab was renamed the Scripps Institution for Biological Research and became part of the University of California. The University of California regents changed the name to Scripps Institution of Oceanography in 1925 in recognition of the breadth of research underway at the institution. From the 1950s through the 1960s, Dr. Roger Revelle was director.

In 1961, President John F. Kennedy asked Dr. Revelle to become the United States' first scientific advisor to Secretary of the Interior Stewart Udall. In 1964, Dr. Revelle became the nation's recognized expert on global

Very early image of George H. Scripps Memorial Marine Biological Laboratory, which was later renamed Scripps Institution of Oceanography, designed by Irving J. Gill, 1910. *Courtesy of the Online Archives of California, OAC.cdlib.org.*

environmental issues and even testified before Congress on several occasions. He also had several television appearances and was the first scientist to present the issues of global warming and the movement of earth's tectonic plates. That same year, 1964, Dr. Revelle accepted an endowed chair at Harvard and the directorship of its new Center for Population Studies. In 1975, he returned to La Jolla and became a professor of science and public policy at the University of California–San Diego. In 1990, Professor Revelle accepted the National Medal of Science from President George H.W. Bush. After his acceptance, he told a reporter: "I'm not a very good scientist, but I've got a lot of imagination. The age of exploration of the sea was just right for me."

Returning to the development of Scripps Institution, to accommodate the growth of the institution, architect Irving Gill was hired to construct what has become known as the Old Scripps Building. This building is an early example of reinforced concrete construction techniques. Within the

concrete walls are steel rods, making the structure earthquake resistant, thus the old building passes today's codes. Skylights and glass brick–embedded floors allowed natural light to penetrate the entire structure. These features, including large windows throughout the building, met Ritter's "exacting specifications for a laboratory in which microscopes and aquaria would receive ample natural illumination."

Although demolishing the Old Scripps Building in 1976 was in consideration, everyone involved with the institution wanted it preserved. To help in their desire for preservation, according to Elizabeth Noble Shor (who wrote a history of the building), wife of Professor Emeritus George Shor, a group of sympathizers "ripped out walls that didn't belong. We risked our lives and signed a document to [save the building]. We replicated the balcony that was in back and placed in front….There are sidewalk lights to give light downstairs. They were covered with concrete. It was Professor Emeritus [in biology] Martin W. Johnson who discovered these as he was chopping away at the concrete….All the windows had been covered with plywood." She also mentioned the skylight in the original plan looking down the center stairs. According to Mrs. Shor, "We hired a consultant who was an expert in rotten concrete, Boris Bresler. Salt water and concrete do not mix! Tanks had leaked at the base of the columns." She went on to describe the building: "Upstairs, in Ritter's office, above the fireplace, was a photo of Charles Darwin." (Dr. William Ritter wrote *Charles Darwin and the Golden Rule*, published posthumously in 1954.) The director's office was in use from 1910 until 1950.

It cost $450,000 to put the building into shape and lots of work from volunteers like the Shors. But the George H. Scripps Memorial Marine Biological Laboratory was saved and has now been declared a National Historic Landmark.

In 1960, when the regents established the San Diego campus of the University of California, Scripps Institution of Oceanography became part of the University of California–San Diego. In 1963, when the new university facilities had been completed, the School of Science and Engineering moved up the hill to the new university campus. Now the university has expanded and includes buildings along the cliffs just above the Old Scripps Building, and a new aquarium remains on the La Jolla Shores campus. Open to the public, the Birch Aquarium at Scripps has a mission "to provide ocean science education, to interpret Scripps Institution of Oceanography research, and to promote ocean conservation." So, if you, dear reader, come to La Jolla, visit the Birch Aquarium and "Explore where the wonders of the ocean come alive!"

Thomas Weyland Vaughan Aquarium, director of SIO from 1924 to 1936. *Courtesy of SIO Archives/UCSD.*

Birch Aquarium, the present SIO Aquarium. *Courtesy of SIO Archives/UCSD.*

A cute story was submitted by Dr. Ursula Bellugi, a professor and director of the Laboratory for Cognitive Neuroscience, the Salk Institute for Biological Science, located on North Torrey Pines Road:

> *We came to La Jolla in 1969, and lived for a year or so in a house on La Jolla Farms Road. We lived in the gatekeeper's cottage of the Blackgold*

Black's Beach. *Courtesy* of *Monica Miller, Pinterest.com.*

Mansion. The mansion became the residence of the chancellor of UCSD, and the gatekeeper's cottage was owned by the Mormon Church and is still a Mormon meeting place. There were no homes in front of the gatekeeper's cottage, the charming little place we lived in, and it was right by the path that went down to Black's Beach. We used to put out the chairs in our back yard and watch the incredible sunsets. Black's Beach was unknown to the world at that time, and was little used, almost entirely by locals who lived above the farms.

One day a woman was arrested by the police for taking off her clothes down in that hidden, secluded place on the beach and bathing in the nude. A wise judge looked over the situation, learned about it, and ruled that since she had walked down that long narrow and forsaken path to a secluded and hidden beach, she was not doing it to be an exhibitionist, so he did not consider it illegal, and let her go without a fine as I remember it. That's how it became a legal nude beach during the year we lived there. By the end of that time, Black's Beach had become known and there were busloads of people from as far away as New York who came to the only legal nude beach around, and the tranquility of the neighborhood was gone.

POSTSCRIPT

Bill and Ruth Black were the original property owners of what is now known as Blackhorse Farms. The Black family used their equestrian ranch for training young Thoroughbreds. Blackhorse was not the family's primary home—it was their escape. William "Bill" Black was an oilman, banker and president of Del Mar Turf Club and was on the Theatre and Arts Foundation Board. Their philanthropic endeavors include an endowment to the cardiovascular laboratory at Scripps Memorial Hospital.

16
The Need for a New Hospital

*D*r. Anita Figueredo said that when she came to La Jolla, there was nothing east of US 101. It was "the wilds." When a new location outside of the town of La Jolla was being considered for Scripps Hospital, Dr. Figueredo said she thought at the time it would be "ridiculous to move the hospital way out there in the wilderness. We needed to keep the hospital in La Jolla." Dr. Figueredo and her husband, Dr. Doyle, lived just below the "in town hospital," their home being on Coast Boulevard facing the ocean. The hospital had about 100 beds and needed to expand. Next door was the Metabolic Clinic. Both the hospital and clinic had been remodeled over and over since their construction in 1924, and they were bursting at the seams. In 1950, a new wing of the hospital opened on Prospect Street, bringing the total number of beds to 105. Plus, there was the need for more and bigger operating rooms, and the original building was in need of extensive remodeling to accommodate upgrades in medical technology. But there was nowhere to add more space to the existing facility. With five thousand new residents pouring into San Diego every month, hospital overcrowding was a countywide phenomenon, not just in La Jolla. In 1956, from August to November, there were no beds available at any hospital in San Diego, and that included not only Scripps Memorial but also Mercy and Sharp Hospitals.

In La Jolla, the only property where a larger hospital could be constructed was on the east side of U.S. Highway 101. This was not La Jolla land. It was San Diego's. And it was truly the wilderness that Dr. Figueredo had talked about. It was the land of sage and chaparral. In those days, there was no Interstate 5, no shopping. It was country—a place, as someone suggested, to perhaps shoot rabbits.

The other issue had to do with the funds from the Ellen Browning Scripps Foundation, which had supported the original Scripps Hospital. They were needed for the new hospital. Since this was the case, the new structure had to, by the tenets of the foundation, be located in La Jolla.

A pamphlet called *La Jolla's Hospital Dilemma: How Did It Come About*, produced by "a non-profit corporation formed by La Jolla citizens for the sole purpose of preserving a community hospital in La Jolla," explained what happened this way:

> *About the time the University of California announced its desire to locate a major new campus in the Torrey Pines area, and city property was being allocated for this and other purposes, a request was made to save a site for future hospital development in this area when the need arose. The proposition was put to the ballot, approved overwhelmingly by the voters, and a 40-acre site set aside on Miramar Rd. for this purpose. It was apparent to all when a projected 25-50,000 new inhabitants had moved into the University area in the next ten years they would then be able to share in the construction cost on a site already provided.*

But in 1959, before the University of California–San Diego was built, the Scripps Memorial Hospital Board of Directors had already voted to abandon Prospect Street altogether and relocate Scripps Memorial to the forty-acre site on Miramar Road. Among the members of the board were La Jolla residents as well as relatives of Miss Scripps (including William Scripps Kellogg). The board recognized that medicine was changing so rapidly and San Diego growing so fast that a move was inevitable. However, the complaint among many La Jollans was that Ellen Browning Scripps had created a hospital in the village of La Jolla in perpetuity and Miramar Road was not La Jolla.

Nevertheless, plans for the move proceeded. And, despite some continued opposition, on April 22, 1964, Judge Eli Levenson decided in favor of the board of directors. Justifying the transition of the La Jolla Hospital to the mesa, despite the tenets of the Scripps Foundation, the judge stated: "The area of the City of San Diego known as La Jolla is not, and never has been a political entity and does not have any official boundary." And further, "The court is satisfied Ellen Browning Scripps, by using the words 'in La Jolla' had in mind a general hospital facility in the general area of La Jolla to service people of all communities without identity."

The hospital moved from Prospect Street to the mesa in 1964. And today the area can hardly be described as "the wilds." As for the original hospital? It is now condominiums.

People of La Jolla

Ellen Revelle's Memories of Early Days in La Jolla

Ellen Virginia Clark Revelle was born on July 31, 1910, in La Jolla, California, the daughter of Rex Brainerd Clark (1876–1955) and Grace Messinger Scripps (1878–1971). Grace Scripps Clark was the daughter of James Edmund Scripps, founder of the *Evening News*, part of the Scripps family newspaper empire. She was the niece of Ellen Browning Scripps and Virginia Scripps, noted La Jolla philanthropists. In 1901, Grace married Rex Clark, and in 1908, the Clarks moved to Julian, where Mr. Clark became a rancher. During the summer months, the Clarks descended into La Jolla, renting houses for their stay.

Mrs. Clark was the first woman to drive a car in Detroit, and she rode horseback from San Diego to Yosemite in the early 1900s. She also rode her horse from their home in Julian to La Jolla. One of the first women to join the Sierra Club, her application was signed by John Muir, the famed naturalist.

Since Ellen was born in the summer, her family was in La Jolla. Her birth actually took place in the cottage in front of her great-aunt Ellen Browning Scripps's house with the assistance of her two great-aunts, after whom she was named: Ellen and Virginia.

Several years later, Ellen was a member of the first class of Scripps College (1931), where she majored in psychology. According to the 1931 Scripps College yearbook, "A scholar and a worker, Ellen has at the same time a cheerful attitude toward life and a well-rounded interest in things social and cultural. Her graduation will take from Scripps one of the most gracious hostesses and interested students."

After college, Ellen perpetuated the family interest in publishing and philanthropy but acquired a new interest in science through her marriage to Roger Revelle. She met Roger while at Scripps College. They married right after her graduation, June 22, 1931, and set up housekeeping at the Scripps Institution of Oceanography in La Jolla, while Roger completed his doctorate in oceanography.

In 1986, the family purchased the *San Diego Daily Transcript*, of which Mrs. Revelle was named publisher in 1993.

The following is Ellen Revelle's life in her own words from an interview conducted in 1981 by Barbara Dawson (La Jolla Historical Society's first president):

My family moved to California from Michigan before I was born and lived first on a Julian ranch, then in San Diego and, finally, in 1916, Pasadena. But summers were always spent in La Jolla, which explains why I, with a July birthday, was born here. Since I did not actually live in La Jolla until after my marriage, my earliest La Jolla memories are all summer ones. The trek down from Pasadena in those olden times was a four-hour expedition, one hour to Santa Ana, the next to a certain old sycamore tree by the dry river bed at San Juan Capistrano, where we always had a picnic lunch and a chance to stretch our legs, then another hour to Oceanside and, finally, the arrival at our destination, whatever little cottage had been rented for that summer.

One of the cottages that I remember was the "Sea Dahlia" at the corner of Kline and Eads. Another one, on Prospect Street, has disappeared, replaced by an IHOP Restaurant. That house belonged to a longtime La Jolla family, the Dearborns. It served as medical offices during the '40s and '50s for Dr. J T Lipe and Dr. Everett Rogers, and, during that period, as I sat in the waiting room with one or another of my four children, I could easily recall taking reluctant naps in the little recess off the main room that served as the receptionist's office, or suffering through the removal from a badly sunburned, gooey shoulder of an undershirt that had gotten stuck. One summer, we were in a house on Draper, just beyond the tennis courts. It was handy to be so close to the playground. At the very end of summer, after the trunks had already been picked up to go back to Pasadena, my brother Bill managed to fall into a nearby fishpond. He returned to the cottage, drippy and more than a little messy for the long drive home.

My family owned, for a while, the two-story redwood house at the north end of Virginia Way called, appropriately, "Edgehill." Mother used to tell of calling the fire department once when Edgehill seemed threatened by a fire in the canyon just east of the house, and of getting the response: "Well, the boys are out to lunch right now, but I'll sure tell 'em as soon as they get back." Thanks to womanpower (and I dimly remember that Virginia Scripps was somehow involved with the episode), the fire was safely out by the time lunch was over!

In the summer of 1920, mother arranged to rent a house from another Pasadenian, the mother of Thaddeus Jones. This house, on the bluff approximately where the north building of White Sands is located, had the name, "Red Raven" (not to be confused with "Red Rest" by the Cove). This was named for a medicinal concoction, rather similar to Pluto Water. Every tray in the house carried advertisements such as, "Drink Red Raven Splits," and there were several large papier-mâché ravens tucked here and there among the antique furniture. There was a wide, unobstructed view north and south and stone steps meandering down to the section of the beach that was called, of course, Jones Beach. Our whole family had always loved that particular beach, which had the name "Whispering Sands" because of the strange sound made by walking on the dry sand. It was a fine place for picnics, shell collecting, walking, and for playing in the protected coves at the north end.

We were allowed to rent the same house the next summer. Probably those two summers in the "Red Raven" convinced my mother that she wanted her own house on that same beach, so she built one that we moved into in mid-summer of 1922. This house, which I have owned since 1940 and enjoy living in, is in a location that was, at the time of its construction, considered by Cousin Floy Kellogg to be "dangerously far out from town." It was rather remote, with few homes very near. There was just empty, sandy land and sand dunes south of us and rough, bare bluffs to the north.

The "Badlands," as we children called the rugged area between us and the "Red Raven," was a fascinating playground. There were canyons, some with quite steep slopes and caves, some of them natural, others dug out by energetic boys. There were trap-door spiders to watch, and the occasional thrill and excitement of finding wicked looking tarantulas. The more serene sand dunes, to the south, were much less exciting, but still fun to play in.

Because of the remote location of the house, my mother, in order to have a telephone and electric service, had to buy her own telephone pole! And, I believe, there is an ancient, unused septic tank lurking somewhere in our garden.

The beach was still a place where men could appear without tops to their bathing suits, which was not allowed at the Cove. However, even when we had a house right above the beach, our daily swims continued to be at the Cove, which was the center of summer life. There was a tradition in the '20s and '30s of family umbrellas being set up at the west end of the cove beach. One feature of the Cove in those days was the raft that was installed every summer, about 100 yards from shore, just a little beyond the reef, with a line out to it from shore, held up in the water by floats. Perhaps it was because of that line across the beach, which divided off the east end, as much as the large sign painted on the cliff at the east side, "Danger! Keep 100 feet back of this rock!" that we never considered going over to sit on that end of the beach. That was for tourists, not regulars like us.

Another activity of the Cove was aquaplaning and later free-boarding back of a motor boat. My mother was persuaded to learn to ride, too, and even convinced to do so minus

the bulky, short dress affair that moderately covered up her "Annette Kellerman" (sort of a body stocking), for fear of becoming entangled.

During all those happy summers in La Jolla, it had never occurred to me that I would become a year-round resident.

Ellen Revelle remained in La Jolla for the rest of her life, with the exception of years spent away on business trips with her husband. Roger Revelle was a legendary statesman of science and the founder of UC San Diego. With Ellen at his side for more than sixty years, Roger became a world-renowned scientist considered one of the pioneers of climate change research. Dr. Revelle's long and varied career took him all over the world and engaged him in a wide range of activities. He won numerous awards and appointments in recognition of his vast scientific research, including a presidential appointment by John F. Kennedy and the National Medal of Science from President George H.W. Bush. In the 1960s, Dr. Revelle inspired a young Al Gore to take on the challenge of climate change. Dr. Revelle was well known for doing the original studies that laid the groundwork for the greenhouse theory. Dr. Revelle died in 1991, leaving a prestigious body of scientific work as his legacy to the world.

On May 6, 2009, Ellen Revelle passed away. She was almost ninety-nine. At the dedication of the Ellen Revelle Pavilion at the UCSD International Center, Roger Revelle had suggested his wife be honored as a "woman of character." He added, "We are honoring her for her gentle ways and her strong will, her self-effacing, modest behavior, her passionate love of justice and her generous support of many good causes."

J T AND GEORGEANNA LIPE

Some time at the end of the nineteenth century, Dr. Cushing, famed physician of Johns Hopkins University Hospital, went to Germany and met Max Broedel, whom he brought back to the University Hospital to do medical illustrations. One of Max Broedel's protégés at the hospital was Susan H. Wilkes, a native of Nashville, Tennessee. Miss Wilkes had attended the Art Students League in New York City prior to receiving her special training as a medical artist under Max Broedel. She returned to Nashville to work at Vanderbilt University, organizing its Department of Medical Illustration and serving on the board of the American Medical Illustrators.

Georgeanna White was also a native of Nashville. Born in 1909, Anna, as she was initially named, was the second child born to George and Anna White. Hers was a prominent family in Nashville who owned the White Trunk and Baggage Company, a manufacturing and sales business in downtown Nashville. Her Scotch-Irish parentage goes back to the Revolutionary War, including the founder of Knoxville, Tennessee, General James White. General White also founded Blount College, now the University of Tennessee, and the First Presbyterian Church of Knoxville.

Young Anna White attended the highly acclaimed Ward-Belmont School for Girls, established in 1875 as Ward Seminary for Young Ladies, rated then as one of the top three educational institutions for women in the nation. Her mother had also attended Ward-Belmont School. Anna began studying drawing seriously. After completing high school, she was accepted by Vanderbilt University, where she completed studies as a premedical student, very unusual for a young lady at that time. However, instead of becoming a physician, Miss White wanted to be a medical illustrator. While a student at the Department of Medical Illustration, Anna came in contact with Susan Wilkes. Miss Wilkes took Anna under her tutelage and offered her special instruction if Anna would do the graphs that Miss Wilkes didn't like to do. This continued for a year, until Miss Wilkes encouraged Anna to take additional training in anatomy during the summer session at the University of Michigan's School of Medicine. This was in 1930, and Anna was the only girl in the class. "I studied from morning till night every day, all that summer," she said. Back at Vanderbilt, in the fall, Anna continued working on the graphs in the morning and spent the afternoons in the anatomy laboratory. She learned to trace blood vessels to muscles, to use an ophthalmoscope to view the interior of the eye; in short, she learned to draw every part of the human anatomy. In her microscopic anatomy class, Anna met a handsome fellow medical student, J T Lipe. She didn't care for him at first due to some tricks he played on her. The story goes that when called on to speak in class, you were required to stand. J T pinned the ankles of the young lady seated across from him so she could not stand. She was terribly embarrassed. Yet, despite this unwanted attention, he eventually won her over and proposed marriage. They were married in 1932 during J T's senior medical year. While her new husband continued his medical education, Anna worked in the pathology department under the auspices of Dr. Goodpasture and Susan Wilkes.

The years following the Depression were hard. In 1932, J T began his medical internship and residency in Rochester, New York, making only

Anna White (Georgeanna Lipe) with her son (author's husband), 1939.
Personal collection.

twenty-five dollars a month. So for the first year of their marriage, Anna remained in Nashville with her parents. After that year, feisty Anna, not wanting to be separated from her husband any longer, moved to Rochester to join him. They lived in one small room on the third floor of a house not far from the hospital and had to climb stairs to use the bathroom, which they had to share with another young couple. Using her initiative and skill, the

young bride earned necessary extra income by creating cards, invitations and announcements using calligraphy and pen-and-ink drawings for churches and organizations in Rochester. While there, she was also captivated by watercolor paintings she had seen in the hospital, which were done by a well-known watercolorist at the time, Roy Mason.

In 1936, Dr. J T Lipe began his medical practice in response to an ad in the *Journal of the American Medical Association* by an older doctor who wanted a young associate. The doctor, Dr. Parker, lived and worked in the small community of La Jolla, California. The location looked "good," so after checking out La Jolla on a map, off they went, heading across the country in a Model A, and driving over three thousand miles at a time when there were no super highways and no regular pit stops or gas stations. While traveling over the sand dunes on the old plank road from Yuma, their car, loaded with books and all their personal belongings, overheated, and the radiator repeatedly boiled over. Upon reaching Scissors Crossing at Coyote Wells, they looked west to the top of the mountains in front of them and wondered how they could get over that impediment. As they started up the grade, it began to get cooler. Without needing further stops to cool the car, they reached the top. Then it was all downhill to San Diego, and they virtually coasted all the way down. It was during this trip Anna decided to change her name to Georgeanna, combining her mother and father's names.

Finally, they arrived in La Jolla. "We got to La Jolla even before we knew how to pronounce it! It was a very small town [population was about four thousand at that time]. There were no tall buildings. Everybody was very friendly, but there were very few young people our age. The saying in those days was that La Jolla was a place where old people came to see their parents! Streets were deserted by 6:00 pm….[T]here were only three houses in the Shores. They were Spanish looking structures. To the south, the Barber Tract was the end of La Jolla."

Their first home was a small cottage located across the alley behind Scripps Memorial Hospital's emergency room. Their front walk led down to Coast Boulevard. Two years later, their first child was born, Steele.

Now, with the beginning of a family, the Lipes purchased a lot on Sea Lane in the Barber Tract for $2,200. Building their new home cost a grand total of $8,000. In 1941, their second child was born, Terry. A few years later, with the pending arrival of a third child, a second story was added to the home, and Susanna was born. In 1957, they traded up to a beachfront home they had always admired around the corner, at the end of Dunemere Drive, No. 311.

Returning to the early days in La Jolla, Georgeanna wrote, "Most everybody we met had been somebody somewhere else. We were completely separated from San Diego. There was a group of young professionals, including a young lawyer, Keith Ferguson, Dr. Roger Revelle from Scripps Institution of Oceanography, and a banker, Sibley Sellew, of La Jolla Savings and Loan, who met together regularly, having parties together and even taking trips together."

Once in La Jolla, Georgeanna Lipe's energy was tapped into her creativity. After raising two of her three children, she began experimenting with oil painting, but she felt she needed to learn a different technique and "loosen up" if she was to continue painting. Turning from the intricate medical illustrations, she experimented with murals on the walls of her own home. Her son remembers growing up in a "circus" bedroom with himself portrayed as the sideshow strong man. After her third child was born, Georgeanna became interested in landscape painting, which required studying a whole new technique. She began by taking lessons with the best oil painter in San Diego at the time, Alfred Mitchell. Then the watercolorist Roy Mason, whom she had admired in Rochester, moved to La Jolla. She started studying with Mr. Mason and converted to watercolors. As her own work progressed, she began attending watercolor workshops sponsored by the Hewitt brothers, featuring the best watercolorists in the country as instructors. The workshops were held all over the world, each offering a new challenge. Some of the places visited included Yosemite, Singapore, Bali, Hong Kong, China, Egypt, Tahiti, Italy, Mexico, France and many that would be impossible to visit in today's world like the Khyber Pass into Pakistan and India.

"It has been said that we find what we are looking for," Georgeanna once wrote. "If we are looking for beauty, we find it everywhere. God has created a beautiful world full of infinite variety, color, and design. Let us enjoy it to the fullest. My hope is to catch the essence and the spirit without being too photographic." Referring to her home, La Jolla, she said, "We are so fortunate to have such a lovely environment in this area to paint."

In 1991, J T died. But Georgeanna continued to relish life with a brave and independent spirit. Patti Keyes writes, "Vibrant with bright dabs of color, crisp detailing and free flowing washes, her works capture the essence and vitality of interesting places and living things. Especially because of her extensive travels, her works are to be found in collections around the globe, and have received numerous awards. She's a prominent member of Watercolor West, a founding member of the San Diego Watercolor Society, the San Diego Art Institute, and the Western Federation of Art."

For many years, Georgeanna's paintings were exhibited at the Knowles Gallery on Girard Avenue across from the La Jolla Elementary School. When Bill and Mary Knowles retired and their gallery was closed, Georgeanna, now eighty-six, missing the camaraderie of her fellow local artists, decided to open her own gallery. On June 6, 1995, she celebrated the grand opening of the Artists' Gallery in the former Knowles Gallery location. Here she was able to exhibit her works and those of her special friends and fellow artists. In celebration of Georgeanna's ninetieth birthday, a gala event was held at the Artists' Gallery, and following the celebration, the gallery's manager, Patti Keyes, noted, "If someone were to write a guidebook on 'How to REALLY LIVE to Ninety and Beyond,' watercolor artist Georgeanna Lipe would be that perfect someone! If you've ever met her or seen her sketching scenes around La Jolla, you'd agree. Indefatigable at ninety years young, she can be found painting, matting and framing her paintings almost daily in her La Jolla home and studio. With a lilt in her step, a glint in her bright green eyes and a smile as quick as her wit and as warm as her heart, Georgeanna is an inspiration to all."

Georgeanna's paintings appear on art festival posters and the Coronado Historical Society poster. Her paintings were purchased by businesses, banks and the La Jolla Country Club. She received commissions faster than she could fill them. One year, her art was the front page of the La Jolla Historical Society's Secret Garden Tour. Many renditions of her art have also been used for the First Presbyterian Church's worship bulletin. Georgeanna's exhibits include Carmel, Sedona, Nashville and Palm Beach. Her paintings grace the walls of homes coast to coast, as well as national corporate offices of Union Oil (now Chevron Corporation), the Hospital Corporation of America and the Copley Collection.

One year, Georgeanna was the grand marshal for the La Jolla Christmas Parade.

Over the years, Georgeanna continued to travel all over the world, always with her paints and sketch pads at her side. One year, her art group went to Italy, and after climbing the hills of Tuscany for ten days, she returned to the United States only to be met in New York with a wheelchair. Sure, she accepted it, laughing all the way through customs, beating her friends and delighting in the joke. If only the airline stewards knew where she had been and what she had done. However, ninety-year-olds aren't supposed to climb mountains, are they?

Georgeanna's 100th birthday found her physically encumbered by old age, but you could never meet a sweeter, happier, more cheerful lady.

Perhaps it is just this cheerfulness that is the lesson for all of us to learn from her life today. Then again, maybe it is La Jolla's proximity to the ocean, the atmosphere and the sunshine all year that inspires such creativity. Georgeanna's philosophy for a long and happy life was "to find something you love to do and work at it—it keeps you interested." Surely a long and happy life is what defined this creative lady. Georgeanna Lipe passed away on March 25, 2012, just missing her 103rd birthday by two months.

"We live in a beautiful world, so let's enjoy it in all its depth of color and infinite variety of design." Truly this was Georgeanna Lipe's philosophy. From the concentrated work as a medical illustrator to the fresh, spontaneous watercolor paintings Georgeanna Lipe became famous for during her life, her work continues to be cherished today. Truly, Georgeanna was La Jolla's living legend.

DOCTORS BILL DOYLE AND ANITA FIGUEREDO

In 1936, Bill Doyle of New York met a remarkable little Costa Rican named Anita Figueredo. They both were attending Long Island College of Medicine. According to her future son-in-law, Dr. Brent Eastman, "Dr. Anita V. Figueredo was born in 1916 in Costa Rica, a country where no woman had ever pursued a medical career, and where, indeed, no medical school existed. She was the granddaughter of a revered and peace-loving general, and daughter of the most acclaimed Costa Rican athlete of his time, Roberto Figueredo, a noted soccer player." However, the marriage did not survive. When Anita was only five years old, she declared her intention to become a physician. Her mother, Sarita Villegas, believing in her daughter's unlikely dream, promptly packed up, and the two set sail for New York. They settled in a tenement building in one of the poorest neighborhoods of New York City, Spanish Harlem. To support the household, Sarita worked in a sweatshop and took in piecework. At just fifteen, less than a decade after arriving in America, Anita was awarded a full scholarship to study premedicine at Barnard, but she turned it down when an admissions officer made a disparaging remark about her high school. She'd been a scholarship student there, too, and never forgot the school's generosity. Instead, she ended up at Manhattanville College, which matched Barnard's offer and created a premed program exclusively for her benefit.

At the age of nineteen, she was one of only four women enrolled at the Long Island College of Medicine. Soon after graduation, the loss of male physicians to World War II offered Anita an unprecedented opportunity as one of the first two female residents in surgery at Memorial Hospital for Cancer and Allied Diseases (now Memorial Sloan-Kettering).

Then, in August 1942, six years after their first meeting, Dr. Anita stood next to Dr. William Doyle, now dressed in the white uniform of a naval officer, at St. Patrick's Cathedral. Dr. Sarita Eastman, Dr. Anita's daughter named after her grandmother, writes, "A faithful and free-thinking Catholic, Dr. Figueredo loved to tell the story of the day God directed her attention toward a lanky, young med school classmate, telling her, in a loud and unequivocal voice, 'That's the one.'" However, only one week after their wedding, Bill sailed away to the South Pacific as the only medical officer on the destroyer *Nicholas*. This was World War II.

Months later, near Guadalcanal, Solomon and Hebrides Islands, he had his "baptism by fire" as a wartime physician. Dr. Eastman writes, "His sister ship, the *DeHaven*, took a bomb between the stacks and sunk within five minutes dragging more than half her crew with her to the bottom of the Coral Sea. One hundred ten men were picked out of the burning debris, and the wounded spread over the splattered deck of the *Nicholas*." Bill Doyle and his medics treated penetrating wounds, fractures and partly severed limbs until the survivors could be put ashore behind friendly lines. Later, he himself developed pneumonia, and his condition became so critical that there was an entry in the ship's log: he was "expected to die." The captain came to pay his last respects.

"But Bill made his way on a transport ship to the new Balboa Naval Hospital in San Diego, California, where he recovered his strength." He returned to New York and his wife. They began their family with the birth first of a boy followed by a girl. But once again, Bill went to sea—this time for the invasion of Japan. Dr. Eastman writes, "His new ship, the *Bellerophon*, was just west of the Panama Canal on August 6, 1945 when the atom bomb was dropped on Hiroshima. Eight days later, the Pacific war was over, and the *Bellerophon* was ordered north to San Diego to await new orders." The wait dragged on, and one day in late September, Lieutenant Doyle boarded a bus marked "La Jolla" and rode to the end of the line. That night he wrote Anita a long letter in which he said:

> *I went back out to La Jolla, the town I spoke of…and covered the whole place in detail. I was that interested. I walked literally miles, from a high*

hill in back of town for a panoramic view, down thru residential districts, looking closely at houses, yards, trees, flowers & lawns, down thru the business district and then for a mile or more along the sea.

Main facts gleaned are: La Jolla is a town of about 8,000 people situated directly on the sea coast, 14 miles north of San Diego—very picturesque, with the unlimited blue expanse of the Pacific as a backdrop for the whole town. There's a modern hospital (of about 100 beds) and an adjoining Metabolic Clinic which is supposed to be nationally famous.

The predominating architecture is heavily Spanish in flavor (white and cream stucco, red tiles, patios, garden walls). Average prices seem to be $9-10,000 for a 3-bedroom house, or $950 for a lot in a good location. There's a moderate boom on, I guess.

I noted 3 doctor's offices all in little one-story separate buildings. There's a nice little Catholic Church, "Mary, Star of the Sea," which appears to be brand new, and in which I lit a candle and said a prayer for us.

Dr. Anita and her husband had been looking for a place in the United States like her native Costa Rica. She had met filmmakers in Washington, D.C., who were from Los Angeles making a film about the navy. She asked them about La Jolla. "You can't make a living there, just professionals," they told her. So, after his brief visit and what she had heard, Dr. Bill Doyle and his wife flew out to visit La Jolla. "I expected it to be green and beautiful," she said. "But from the plane, I looked down and it was brown." They stayed at the Casa de Mañana, which was a hotel at the time. For years a popular place for tourists, it was "where more formal entertainment was done." The architect was Edgar V. Ullrich. He was "designing while constructing" from 1923 to 1924, building a Mission-style hotel and cottages on a property "that cornered on the pool, looking both ways along the coast and out on the horizon." They called the horizon "sea dreams." In 1947, Dr. Doyle described the Casa as having spacious grounds and "dripping with Bougainvilleas, Trumpet vines, and there was an exquisite patio with bull fight posters….[I]t was really as if you were actually in old Spain." The Casa became a place of elegance, good taste and good food. It was like a resort offering visitors not only sun, sand and sea but also horseback riding, social events and balls.

On a bus ride, the Doyles passed a house where someone was putting up a for sale sign. "We stopped the bus and got out and bought the house." (That first house cost $17,000.)

"Medical specialists were in San Diego, not La Jolla," Dr. Anita Figueredo said. She was advised, "Eventually you will find pediatric practice in La

Home belonging to Drs. Anita and William Doyle on South Coast Boulevard. Her office was at the rear on Coast Boulevard and still bears the Dr. Anita Figueredo plaque at the entrance. *Personal collection.*

Jolla, but now there are just the elderly. For you, Dr. Figueredo, no woman has opened a belly and I don't believe ever will." But, Dr. Anita said, "By the time our kids were born, younger families were moving in."

Anita Figueredo Doyle was thirty-one years old and Bill Doyle thirty-two when, in 1947, they settled in La Jolla, a continent away from all their family and friends. Dr. Doyle became the first pediatrician north of downtown San Diego, and his practice stretched from Mission Beach to Oceanside. And Dr. Anita became the first female surgeon in the county.

By the mid-1950s, they had purchased a two-story Spanish villa directly across the street from the ocean. Here they raised their nine children. Dr. Anita established her office in the guesthouse so she could manage her time on a triangular trajectory between home, office and hospital, the latter being just above and behind their home. "Dr. Figueredo maintained a demanding practice in the field of oncologic surgery throughout her motherhood. She once walked straight from the OR to the maternity ward, where she gave birth and returned to make rounds on her patient the following morning."

Dr. Anita Figueredo and Saint Teresa in Calcutta, 1966. *Courtesy of Dr. Sarita Eastman.*

In 1967, Dr. Bill Doyle, as chief of the medical staff, presided over the move of Scripps Hospital from Prospect Street to the chaparral-covered mesa north of town.

Technically, Dr. Figueredo revolutionized the approach to cancer in her community, not only by applying the surgical techniques she learned at Memorial but also with concepts of prevention and the cancer detection exam, including the Pap smear, which she learned from Dr. Papanicolaou himself. Dr. Figueredo retired from the operating room in the mid-1970s. Nevertheless, she continued to care for many patients in her office beyond her eightieth birthday.

Dr. Anita was also a fierce proponent of women's rights to higher education. She was a founding member of the board of trustees of San Diego College for Women, later the University of San Diego, and served in that capacity for forty years.

Dr. Figueredo's daughter Dr. Sarita Eastman writes, "Dr. Figueredo's great passion in life, aside from medicine and her family, was humanitarianism, a calling that produced a four-decade-long friendship with Mother Teresa of Calcutta, who called her 'The Smiling Apostle of

Charity.' Dr. Figueredo was among Mother Teresa's few intimates, and the two women rendezvoused all over the world in service of the poor. It was Dr. Figueredo who lobbied the nun to establish her mission in Tijuana, Mexico, which now serves as the world headquarters for Mother Teresa's Missionaries of Charity Fathers. ('This is the answer to years of prayer,' she told *The New York Times*.) In 1982, Dr. Figueredo founded a charity of her own, Friends of the Poor, originally devoted to the needy residents of Tijuana and San Diego, and now expanded to three continents."

Meanwhile, in the village of La Jolla, a civic orchestra was being founded. When Peter Nicoloff moved to La Jolla, he could not believe that his new community did not have an orchestra. "Nobody went to San Diego in those days." A professional musician himself, Mr. Nicoloff founded the La Jolla Civic Orchestra and became its director. Initially, the orchestra was composed of just local folk; Dr. Figueredo became its president in 1960. "During my tenure, we thought we should be working together with UCSD, which had recently opened. We also had a civic chorus. I went around to all the churches and their choirs and asked if they would cooperate. They said yes." This all proves that doctors who moved to La Jolla in the past did not just practice medicine. They practiced enhancing their new hometown, too, and we are so grateful.

Dr. Anita Figueredo passed away on February 19, 2010, from natural causes at the age of ninety-three. A remarkable lady and a gift to La Jolla.

GREGORY PECK

Eldred Gregory Peck was born in La Jolla. His mother, Bernice Mary (Ayres), and father, Gregory Pearl Peck, divorced when he was five years old. His father was a chemist and druggist in La Jolla, but after the divorce, Gregory, their only child, went to live with his grandmother in La Jolla and attended the local schools. His fondest memories were of his grandmother taking him to the movies every week and of his dog, which followed him everywhere.

His education began at Little Red Schoolhouse, later at La Jolla Elementary. Then he was sent to St. John's Military Academy in Los Angeles but returned to La Jolla to finish high school. After graduation, Gregory attended the University of California–Berkeley. Initially, he was registered as premed. However, it wasn't long before he changed his major. While at Berkley, Gregory was smitten by the acting bug and decided to change the focus of his studies.

In 1939, Gregory moved to New York City and for three years was enrolled at the Playhouse School of Dramatics. His debut on Broadway was in *The Morning Star* (1942). Actor and producer Casey Robinson saw this young, handsome man with what he described as a "magnificent speaking voice" and knew he had to cast him in a film he was preparing in Hollywood. A strange event had taken place the year before. David O. Selznick, best known for *Gone with the Wind,* had given Gregory a screen test and flatly rejected him. But a year later, Gregory was in Hollywood where he debuted in the RKO film *Days of Glory* (1944). Gregory Peck's career was on its way. However, when his RKO contract was sold, who should make the purchase but Mr. Selznick? This producer then claimed it was he, not Robinson, who discovered Gregory Peck.

Soon Gregory was in demand. He appeared in many films, even receiving his first Academy Award nomination as Best Actor in 1944. But the pinnacle of his career came in 1962, when he won an Oscar for Best Actor for his role as a trial lawyer in *To Kill a Mockingbird.* According to Dennis G. Wills (owner of La Jolla's D.G. Wills Books), when he thanked Gregory for his portrayal of Atticus Finch, Mr. Peck replied that this was his favorite role and that he had never felt closer to a character and felt blessed to have had the opportunity to portray such a person. "He also gracefully pointed out that his Best Actor Oscar was due in great part due to the poignant scene at the conclusion of trial in *To Kill A Mockingbird.* Atticus Finch is leaving the courtroom, the whites sitting on the ground level of the courtroom have already left, only the blacks, forced to sit in the balcony, remained, grateful that a white attorney would defend a black man, Tom Robinson [played by Bruck Peters, who later delivered the eulogy at Mr. Peck's funeral in 2003]. As Atticus is leaving, Rev. Sykes [Bill Walker] advises Atticus' children Scout [Mary Badham] and her brother Jem [Phillip Alford], the only whites sitting in the balcony, to stand up, as 'your father's passin.'" According to Mr. Wills, Mr. Peck told him it was the impact of that scene that "wrapped up" the Oscar. Mr. Wills concluded, "La Jolla thanks you, Eldred Gregory Peck, not only for the legacy of the La Jolla Playhouse, which you helped found and maintain, but for the sweet, enduring humanity you brought to your profession."

In 1947, Gregory Peck established the La Jolla Playhouse with actors Mel Ferrer and Dorothy McGuire. He also produced a few films. By the end of his life, he had appeared in twenty-six films and was considered "the moral conscience of the silver screen," as his performances embodied the virtues of strength, conviction and intelligence. Off the screen, too, Gregory always seemed

to be playing the role of hero. He served as chairman of the American Cancer Society and was a charter member of the National Council of the Arts. In 1968, Lyndon Johnson presented him with the Presidential Medal of Freedom, the nation's highest civilian award.

"I'm not a do-gooder," he insisted after learning that he was the recipient of the 1967 Jean Hersholt Humanitarian Award, a special Academy Award. "It embarrassed me to be classified as a humanitarian. I simply take part in activities that I believe in."

In 2003, La Jolla lost its own favorite son. Gregory Peck died just days after his character in *To Kill a Mockingbird* was voted the greatest hero in Hollywood history. He was eighty-seven. Clearly, the many times his grandmother took him to see the latest films at the local La Jolla theater instilled in Gregory a lifelong love of movies.

The three founders of the La Jolla Playhouse, Mel Ferrer, Dorothy McGuire and Gregory Peck. *Courtesy of La Jolla Playhouse.*

CLIFFORD PARKER ROBERTSON III

On September 9, 1925, a young man who would become a great actor and pilot was born. His name was Clifford Parker Robertson III. Sadly, his mother, a single parent, passed away when Cliff was only two and a half years old. He was raised by his grandmother and an uncle in La Jolla.

One day, he said, "I saw a little yellow airplane doing aerobatics over our house. My uncle and another man were standing there watching the aerobatics, wagging their heads sagely, and one said, 'You'll never get

me up in one of those little airplanes.' Then the little airplane turned southward and started to hum its way home. We got into the Ford alongside the curb and it wouldn't start. In my little mind, I was thinking, 'What's wrong with this picture?' I think I began to become a partisan for aviation at an early age. I was defending it then, and I still am."

When he was fourteen, during the summer when there was no school, he would ride his bicycle to the "little sleepy airport" in San Diego some thirteen miles away from La Jolla.

"Piek's Airport had one little sandy runway," he said. "I would go and work eight hours a day cleaning airplanes and engine parts and never got paid a nickel, but every third or fourth day, the chief pilot would say, 'Cliff, go get your cushion.' I was short for my age. I'd take my cushion out to a little red Piper Cub, and he'd take me up for 15 minutes and let me at the controls once we took off. I thought I was the ace of aces. It was a magic time." Cliff added, "I never dreamed of one day owning a plane."

"Flying is freedom," Cliff once said. "It's the essence of the good life." But flying was put on hold.

"I acted in class plays to get out of having to do after-school chores," he confessed. In his senior year at La Jolla High School, Cliff was the Grand Sagacious Skull (president) of Skull and Bauble, the dramatic society of LJHS. But when he enrolled at Antioch College in Ohio, it was to pursue writing. He got a job on the town paper, where someone said his writing style would be better suited for the theater. Cliff liked the idea, but all plans were put on hold with the outbreak of World War II.

He figured he'd be a natural as a navy pilot, but when one of his eyes tested at less than 20-20, he was forced to take another route. He joined the merchant marines and saw action in the South Pacific, the Mediterranean, the North Atlantic and France. "It was a dangerous way to spend the war," he said, "but I'm still here. Not everybody was so lucky."

Back in civilian life, Cliff went to New York to pursue his dream of writing for the theater. Instead, he fell into acting "because it was there and it was something I could do." He got a break in 1950 when he joined a national touring company for the play *Mister Roberts*. That lasted two years. Then he was cast on Broadway in Joshua Logan's *The Wisteria Trees*, with Helen Hayes.

In 1955, Cliff Robertson made his screen debut in the Logan-directed movie version of *Picnic*. That same year, he drew praise as Joan Crawford's schizophrenic boyfriend in *Autumn Leaves*. In 1963 he was hand-picked by President Kennedy to portray him in the World War II action biopic *PT*

109. Two years later, he earned an Emmy award for his role in the TV play *The Game.*

Cliff copped acting's highest prize in 1968 when he won an Oscar for the lead role in *Charly,* in which he played an intellectually disabled adult who is given temporary mental powers following a scientific experiment. The Academy Award for Best Actor was presented to Cliff by fellow La Jollan Gregory Peck.

In all, Cliff was in seventy movies, including Tobey Maguire's Uncle Ben in *Spiderman,* and Stephen King's *Riding the Bullet.* "But," he said, "show business is like a bumpy bus ride. Sometimes you find yourself temporarily juggled out of your seat and holding onto a strap. But the main idea is to hang in there and not be shoved out the door."

Where Cliff truly held on to the strap was in his love of flying. "There's synergism in an activity like aviation. You must give back what you take out." And those aren't just words. In 1969, when a civil war was raging in Nigeria, Cliff helped organize an effort to fly food and medical supplies into Biafra, which was caught in the middle of the conflict.

Then, in 1978, when a famine hit Ethiopia, Cliff organized flights of supplies to this ravaged country. Four years later, he received the L.P. Sharples Award from the Aircraft Owners and Pilots Association for his many contributions to aviation. Other honors came from the U.S. Air Force, the National Soaring Museum and the National Aviation Club. He also gave presentations at aviation programs.

In the '80s, Cliff decided to put to test the legend of Gustave Whitehead, the German immigrant who supposedly built and flew an airplane in Bridgeport, Connecticut, in 1901, two years before the Wright brothers. Cliff rebuilt Whitehead's craft and piloted it himself down a runway in Bridgeport. It lifted off the trailer holding it and briefly took flight, lending credence to the story. "We'll never take away the rightful role of the Wright brothers," Cliff said, "but if this poor little German immigrant did indeed get an airplane to go up and fly one day, then let's give him the recognition he deserves." These remarks are consistent with Cliff Robertson's on-screen persona. He's often depicted as solid-looking, intense and earnest—an intelligent and reliable everyman.

Because of his passion for flying, he poured his movie earnings into buying and restoring World War I and II planes. He restored a Belgian Submarine Spitfire Mark 9 and three Tiger Moths. Later, he acquired a Messerschmitt BF108, a 1930s four-seat executive liaison military aircraft, a French Stampe and his main transportation, a Beech Baron. Cliff held a Nevada State Soaring Record in his Grob Astir two-place glider. He was also a student of Steele Lipe

(the author's husband) at a week's soaring meet north of Reno called a cross-country camp. It was a time when techniques were introduced for cross-country flying; cutting the psychological apron strings to the home glider port was paramount. At that time, Cliff was flying a single-seat glider, not his twin Grob.

At least once a year, Cliff would fly across the country from his home on Long Island back to La Jolla and the house he loved, the Barber House. One year, as he flew over New York City, he saw smoke. Immediately, he was radioed to come down. All planes were to land as quickly as possible. It was September 11, 2001. He spent three days at a small airport in New Jersey confined to his plane before being given permission to continue his flight to California.

In 2002, Cliff said, "Even though my work keeps me moving around the globe, in my heart, I never left La Jolla. These are my roots and I will never sever them. I feel that my house represents not only the early Spanish architectural heritage, but it represents La Jolla in its once sleepy, warm and friendly time. I hope these grounds will continue to be a reminder to all La Jollans, what once was and what should be appreciated."

But ultimately, he was getting too old to make these flights across the country, and his daughters were both in the East. He had to make the difficult decision. He had to sell his beloved home in La Jolla.

Cliff Robertson and Barbara Dawson (first president of La Jolla Historical Society). *Courtesy of Barbara Dawson Archives.*

Then, the day after his eighty-eighth birthday, September 10, 2011, Cliff Robertson died. At the time a resident of Water Mill, New York, he died at Stony Brook University Medical Center. Nevertheless, Cliff will always be considered a true La Jollan.

Following his passing, the alumni association of his alma mater, La Jolla High School, was informed that Cliff had named the association as beneficiary of a Charitable Remainder Trust he created in 2003. The funds were designated to establish a Cliff Robertson Acting Award. This award was to be given annually to deserving La Jolla High School drama students and was a sufficient enough amount to be given in perpetuity. Just one more act that defines this man as being generous and so special.

DAVID WEISS

There is no "how-to" when it comes to writing, but there is a writer who has a track record of proven success that exemplifies writing at its finest—and historical fiction writing in particular. Eleven of David Weiss's historical fiction books have been published in the United States and nine in the United Kingdom. They appear in twenty-five languages and eighty editions. Weiss was also recommended for a Pulitzer Prize. His third book, called *Naked Came I*, about the sculptor Rodin, was a bestseller and sold more than six million copies. Hungary has published six of his novels, including *Sacred and Profane*, one of the finest works about Mozart. The Czech Republic, which also published six of Weiss's novels in the past, has now bought his works on Mozart, Rembrandt and Titian for publication in new editions.

Weiss was not the least intimidated by such grand personages of the past as Mozart, Beethoven, Christopher Wren or Rodin, to name but a few of his protagonists. "People say to me, 'How dare you write fiction about these famous people?' But I repeat: I am not awed by them," Weiss said. "I respect and admire them, but to me they are human beings like the rest of us. They behaved like others in their time, spoke like them, looked like them. It was only when they expressed themselves in their art that they were different." Clearly, Weiss was attracted to the concept of creativity, and he explored the history of art and the individual artists who contributed their talents to the world. Nor was his appreciation confined to one artistic endeavor. Weiss explored all forms of creativity, including music, painting, sculpture, architecture, dance and even medicine, as in the case of his work on Dr. William Harvey, *Physician Extraordinary*.

David Weiss. *Personal collection.*

Writing was a passion as well as therapy for this gentle and sensitive man who chose to make La Jolla his home in the '70s and never regretted it. His childhood was not easy. His mother died when he was three, and a year later, his father, a painter, died. Placed in his aunt's custody, young David grew up in a stormy family environment in Philadelphia. His aunt's restaurant, across the street from the Academy of Music, specialized in Russian cuisine, which appealed to conductor Leopold Stokowski and to his guests, including Igor Stravinsky, Sergei Rachmaninoff and Georges Enesco. Young David, who paid fifty cents to hear the music recitals, was introduced to these great artists of the early twentieth century when they came to celebrate at the restaurant.

Philadelphia was also a theater town. When he was nine, Weiss saw Al Jolson perform. This exposure to the arts clearly left an impression on the young man despite his unhappy home life. At sixteen, he left school and went to work, holding all kinds of jobs, such as store clerk, stevedore, meat-loader, actor, basketball and swimming instructor, camp director, ghostwriter, lifeguard and tennis pro. Apropos this period of his life, he is quoted as saying, "It is a cliché today for a writer to have had many jobs in search of experience, and I have stretched this cliché to the breaking point." Eventually, he found his way back into academia and worked his way through Temple University, obtaining a degree in merchandising from the School of Business Administration.

At the end of World War II, Weiss enrolled in the New School of Social Research (which became the Actors Studio) in New York City. His fellow

students included Tony Curtis and Marlon Brando, as well as Weiss's future bride, playwright and poet Stymean Karlen.

For fourteen years, Weiss worked for film producer David O. Selznick, the last seven as his story editor, working on such films as *A Farewell to Arms* and *Tender Is the Night*. He spent a year with General Omar Bradley helping him write his memoirs. In 1953, he finally reached his ambition; that is, to be a full-time novelist. His first book, *The Guilt Makers*, was a heavy social commentary on concentration camps. But "once I got into historical novels, my interest in social novels diminished," Weiss said. "My political views never changed, but I learned that the world is much bigger than I am. I decided that if my books help the world, fine—but don't bet on it."

Maybe his books have not changed this world, but they have offered readers a glimpse into another world of order, beauty and clarity as experienced by the greatest artists of modern time. "Writing novels is making order out of what seems to be chaos," he explained. "My life is a triumph of perseverance over common sense."

With a daily disciplined schedule of writing, Weiss saw his talent as a privilege, and he respected that muse who lurks within. We readers are the fortunate beneficiaries. His latest book was to be very different, his own memoir, titled *Forever and After*. He described this work as a romantic and passionate love story. Stymean Karlen, his wife of more than half a century, died in 1998. Weiss described this book, in part, as "a dramatic contrast to the dysfunctional era where divorce is a disease, and tales of rape, violence and incest turn off many readers." According to one critic who had read the manuscript, Weiss engaged the reader "by showing how two loving young streams flower in their own ways. Apart, then together, defiantly against the conventions, hard times, producing through their mingling an interwoven fabric that is beautiful and poignant on their own terms. When Stymean's life is blended with [David's], the two lives become dramatic and absorbing. I thoroughly enjoyed the book, but more than that, I was deeply moved." Throughout his books, he integrated poems written by Stymean, usually as a prologue to the novel.

This last book would have been a journey worth taking, with insight into the twentieth century through meeting Weiss on his own turf. Sadly, the book was never published. On November 29, 2002, David Weiss died in La Jolla at the age of ninety-three.

> *To be myself*
> *Without*
> *The struggle To be.*
> —*Stymean Karlen*

Theodor Geisel, aka Dr. Seuss

If you don't get imagination as a child, you probably never will.

I like nonsense. It wakes up the brain cells.
Fantasy is a necessary ingredient in living.
It's a way of looking at life through the wrong end of a telescope.
Which is what I do.
And that enables you to laugh at life's realities.

Ted Geisel was born in 1904. His mother, Henrietta, as a young girl, sold pies in her family's bakery. To lull her children, Ted and his sister, Marnie, to sleep at night, she would chant a long list of pies. Ted told his biographers Judith and Neil Morgan (both La Jolla journalists and old friends of Ted Geisel), his mother was responsible "for the rhythms in which I write and the urgency with which I do it." Ted's father was from a prominent Springfield, Massachusetts family. Two generations of Geisels were master brewers—that is, until Prohibition. In 1931, Ted's father, Theodor Robert Geisel, known as T.R., was appointed as Springfield's superintendent of parks, a position he held for thirty years. Part of the park was the Springfield Zoo. Young Ted often visited the zoo with his sketch pad. From 1926 to 1927, Ted was in Paris. Two years prior to Ted's arrival, André Breton had started a movement called Surrealism. This involved uniting the conscious and unconscious mind. For Breton, the unconscious was the source of imagination. This period of time in Paris was special for Ted and one he

never forgot. The idea of surrealistic art would be integrated into his work for the rest of his life.

Ted attended Oxford and took a class titled "Anglo-Saxon for Beginners." This is what he scribbled while there:

I do not like you, Dr. Fell.
The reason why I cannot tell.
But this I know and know full well,
I do not like you, Dr. Fell!

(Doesn't the rhythm remind you of *Green Eggs and Ham*? "I do not eat them in a house, I do not like them with a mouse. I do not like them Sam-I-Am. I do not like green eggs and ham.")

But it was not Ted who wrote the original. This is a poem dating back 250 years written by Tom Brown about his professor Dr. John Fell. Nevertheless, it clearly reflects Ted's feeling for the class.

Also in this class was a young lady named Helen. Early on, watching Ted, she recognized his love of drawing and told him he was crazy to think of becoming a professor. He must have listened to her because soon he had his first professional sale. It was a cartoon for the *Saturday Evening Post*. He was paid twenty-five dollars, and the cartoon was published July 16, 1927. This was all the encouragement he needed, so he moved to New York City at twenty-three. By the end of the year, he was earning seventy-five dollars a week as a writer and artist for a magazine called *Judge*. Now employed, he proposed to Helen. They were married in November.

From the cover of *Judge* to other leading magazines, Ted's cartoons were soon on the covers of several leading magazines, including *Life*.

In 1928, on a trip west, Ted and Helen fell in love with La Jolla. Ted called it a place where the climate would allow him to "walk around outside in my pajamas." But it wasn't quite time for them to move.

When the Great Depression descended, the Geisels survived by Ted doing advertising for Standard Oil (1928–53). "It wasn't the greatest pay, but it covered my overhead so I could experiment with my drawings," Ted told the Morgans.

In the summer of 1936, Ted and Helen sailed for a vacation trip to Europe. But as he boarded the ship for their return trip to the United States, he couldn't help but realize that a man called Hitler was threatening his ancestral home as well as all of Europe. Once back in New York, he showed a politically charged cartoon to a friend. His friend shared the cartoon with

the editor of a "popular front" paper called *PM*. As a result, Ted became the paper's editorial cartoonist. The first cartoon appeared January 30, 1941.

During World War II, Ted also worked at the U.S Military's Office of Information and Education. He created animated training films for soldiers getting ready for war using an animated funny character as a trainer. His own art was put on hold. On his own, however, it was always art, sketches on scraps of paper, on menus, on leftover stationery, that kept Ted occupied. After the war, it was back to drawing and writing to share with all of us. For Ted, art wasn't a vocation. It was a way of life, and it must have been a relief to return to his passion as a livelihood.

Finally, twenty years after their first visit, the Geisels returned to La Jolla and purchased what was nicknamed "La Jolla's Tower." This was a run-down structure built for observation atop Mount Soledad. The Geisels built their home around this tower. World War II had ended, and with the postwar baby boom, it was a perfect time to write children's books. However, his first book, *And to Think That I Saw It on Mulberry Street*, which he both wrote and illustrated, was turned down by twenty-seven publishers before a friend

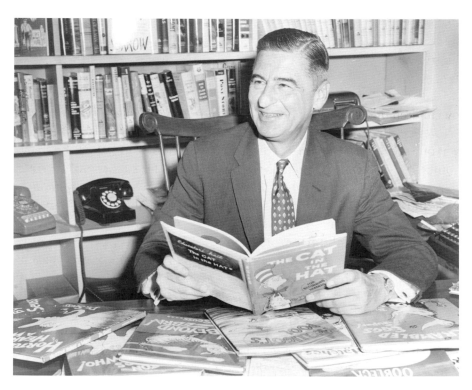

Theodore Seuss Geisel (Dr. Seuss). *Library of Congress.*

had him send it to Vanguard Press. Of course, the book was a success. Thus began Ted's new career. "I'm subversive as hell. I've always had a mistrust of adults."

Soon he and Helen became enmeshed in La Jolla's society and in its various artistic institutions, including the La Jolla Art Museum (now the Museum of Contemporary Art) and the La Jolla Playhouse. Of course, this also created a "playground" for Ted to tease his fellow La Jollans artistically. He called himself a "bird watcher on the social scene." Most of these paintings, however, were hidden until after his death.

When *The Cat in the Hat* came out, Ted Geisel had already been writing children's books for twenty years. In 2007, *U.S. News & World Report* wrote, "In the 50 years since *The Cat in the Hat* exploded onto the children's book scene, Theodor Seuss Geisel has become a central character in the American literary mythology, sharing the pantheon with the likes of Mark Twain and F. Scott Fitzgerald. Of his many imaginative stories, *The Cat in the Hat* remains the most iconic." For years, this famous cat became more than a book character for Ted. He seemed to morph into his alter ego, resurfacing in several paintings as a surrealistic rendition of himself. Disguised as nonsense, these paintings combine Ted's imagination with his thoughtful understanding of human nature. Truth was hiding behind art. Remember his study of surrealism in Paris? Now it was coming through and not just for himself but for all of us to enjoy!

Ted and Helen did not have any children. Often, when he was surrounded by children (including the author's husband), he would feel uncomfortable. However, despite this discomfort, he really cared about children. But there was one special child he loved, a nephew, Ted Owens. Named after his uncle, young Ted would spend hours with Uncle Ted in his studio, and together, they would paint. This style of painting the two shared, in the opinion of Neil and Judith Morgan, could be called "Seussian Abstraction." Another description of this kind of art was the American art movement occurring at this time called "abstract expressionism," where the artist projects his or her emotional experience onto the canvas. In a sense, this is art exposing a journey happening within the artist, his feelings and reactions to his surroundings. What went on the canvas was an event, and often the artist was as surprised as the viewer. Consider the artist de Kooning as an example of this concept.

Speaking of his uncle, young Ted said, "He believed that life was a place to have fun." And have fun, they did. When Ted was a teenager, he attended the Art Center College of Design in Pasadena. "I was living and breathing

painting and art because Uncle Ted said painting has to be full-time if you're going to be any good."

In 1967, Ted's wife, Helen, died. When he remarried, it was to an old friend, Audrey Stone.

Always humble, Ted once wrote, "If I were a genius, I wouldn't have to work so hard." Ted also said, "When I can't find a word I want, I think one up." The same went for his art. "Kids exaggerate the same way I do," he said. "They overlook things they can't draw, their pencils slip and they get funny effects. I've learned to incorporate my pencil slips into my style." Doesn't this sound like surrealism?

Sometimes his inner thoughts found expression in poetry. The following is a poignant poem Ted wrote called *A Prayer for a Child*:

From here in earth,
From my small place
I ask of You
Way out in space:
Please tell all men
In every land
What You and I
Both understand.

Please tell all men
That peace is Good.
That's all
That need be understood.
In every world
In Your great sky
(We understand
Both You and I.)

Ted Geisel died in La Jolla on September 24, 1991. He was eighty-seven years young. At the time of his death, Ted had written and illustrated forty-four children's books, including such all-time favorites as *Green Eggs and Ham, Oh, the Places You'll Go, Fox in Socks* and *How the Grinch Stole Christmas.* His books have been translated into more than fifteen languages, and over 200 million copies have found their way into hearts of old and young alike around the world. He also won two Academy Awards, two Emmys, a Peabody Award and the Pulitzer Prize.

His second wife, Audrey, has made sure his legacy will never leave the hearts and minds of all who loved his work during his life and will continue to do so with his books and paintings still in print. "I have said that Ted knew he would leave big footprints after he was gone, but he couldn't possibly have known the astonishing impact his legacy would have on the world of art, literature, pop, and high culture."

Every March 2, the day of his birth, Ted Geisel is still being honored by children and adults all over the world. According to Steven Walts, a father and educator in Virginia, "Dr. Seuss stories are written in such a way that they can be interpreted at different levels of sophistication by readers of all ages."

Of particular interest to the author is the book *Dr. Seuss's Secrets of the Deep*. This book illustrates the lost, forgotten and hidden works of Theodor Seuss Geisel, published in 2010.

There Was Another Cove in La Jolla

*D*espite efforts by townspeople, the Cove Theater, 7730 Girard Avenue, closed on January 16, 2003.

The Cove Theatre was built in 1948 in the Colonial Revival style and managed by Edward "Spence" Wilson until the final two years. In its last ten years, the building had five different owners. The Cove supplanted the Granada Theater, which was located just south of the corner of Girard and Wall Streets.

We must share some information about this special man, Spence Wilson. Edward Spencer Wilson was born on August 22, 1912, in Ransburg, California, in the high desert. His father had been a captain in the merchant marines and then moved to Randsburg, where he worked in gold mining. When Spence was eight years old, Will Rogers Sr. was making silent films in Randsburg and included Spence as an extra in some of those films. This is where he first became interested in movies.

Spencer's uncle Harry Wilson moved to La Jolla in 1915 and opened the Western Union Telegraph Company office. Spence and his father often came to La Jolla to visit Uncle Harry and couldn't resist ultimately moving to La Jolla permanently. Spence's first job was delivering telegrams by bicycle for his uncle.

In 1929, Spence began working at the Granada Theater while a sophomore at La Jolla High School. He graduated from LJHS in 1931. During World War II, Spencer served in the U.S. Navy.

Upon his return, he became manager of the Granada Theatre and stayed until it closed in 1952. Then he managed its replacement, the Cove, for another forty years before retiring. During this time, Spence, as he was

Young Spencer Wilson as a Western Union delivery boy for his uncle. *Courtesy of Barbara Dawson Archives.*

called, became so popular in La Jolla that he came to be known as "Mr. La Jolla." Described as tough but loving, Spence taught generations of La Jollans about work ethic, manners and respect for others.

But let us return to the Cove Theater on that sad day of its closing. On January 16, 2003, about one hundred people poured into the Cove Theater for the 7:00 p.m. showing of *Adaptation*, starring Nicolas Cage. Many customers reminisced in the lobby, some even shedding tears. Before the start of the show, Monika Seitz, house manager for the final two years, thanked the audience for their support and asked if anyone wanted to share memories of the theater. One man said he went to the Cove on his first date at the age of thirteen and is now happily married to the woman. Another said she first viewed *A Hard Day's Night* and other memorable movies at the Cove. One woman said her husband had been a crossing guard for the La Jolla schools and fondly remembers getting free tickets to the movie theater as a young boy.

Although original manager Spence Wilson couldn't attend the final curtain call, "he was there in spirit," said Monika Seitz.

A twenty-minute short by a local San Diegan was also shown before the movie.

Cove enthusiast Philomene Offen, saddened when she heard the theater would close, spent weeks tirelessly trying to organize a grass-roots effort to save

Spencer Wilson in later years. *Personal collection.*

it. A longtime La Jolla resident, Philomene had seen nearly every movie played at the Cove. She said she felt like a "guest" at the Cove Theater, instead of part of a herd of "cattle" at a multiplex theater. The small theater was truly an important entertainment asset for La Jolla. One recommendation she made was to create a special section for adults over twenty-one years of age and allow drinks and food, as several other small theaters across the country have done to generate more money. (This is exactly what the new theater, THE LOT, has done. As its ad says, "If you are looking for a mix of relaxation, leisure, craft cocktails, locally sourced coffees, sustainable and elevated cuisine and the latest blockbuster movies and independent films, we've got what you are looking for at THE LOT—La Jolla's destination for an epic and artistic lifestyle experience like no other.")

But, as Philomene Offen said, "While change is inevitable, it doesn't mean the community shouldn't try to preserve the vestiges of the place and the attributes that made the town a desirable place to live in the first time. And the Cove Theater has been one of those places."

MEMORIES OF THE COVE: AN APPRECIATION

Patty and Steele Lipe

Every Saturday afternoon, we stood outside on the sidewalk in front of the Cove Theatre and waited in long lines to buy tickets from the little ticket booth for the matinee. We were children, and our parents allowed us the treat of the Saturday matinee if we behaved. The matinee movie was not the regular movie shown in the evenings for the grown-ups but was selected by the management (Spence Wilson) for the specific enjoyment of us children.

In those days, there was always the newsreel before the main feature, except for the Saturday matinees. On Saturday, the films were dedicated to the kids, so short comics such as Looney Tunes with Bugs Bunny, Elmer Fudd, Daffy Duck, Yosemite Sam and the Walt Disney Clan or some similar venue came first. Then we would watch a short serial such as the Lone Ranger and his sidekick Tonto and finally the main attraction of the day.

It seems to me [Steele] that it was more important for many of us to see what had befallen the Lone Ranger and the heroine he was trying to save from the bad guys than the main feature. We would all talk about what might happen this week as we stood in line to buy our twenty-five-cent tickets. Of course, if we were naughty, the best discipline was to deny us the privilege of the Saturday movie.

Many of us walked with our friends or rode our bicycles from home and parked them in the bike racks alongside the building on the right side next to the parking lot. We never needed to lock them.

It was perfectly safe to be at the theater without our parents. Mr. Spencer Wilson was the Colonel of the Cove. He would surely supervise and control any misbehavior. That we knew and respected.

Some parents did come Saturday afternoon. They had babies with them whom they could control behind the glass window in the "crying room" separating them and the babies' cries from the rest of us.

I [Patty] remember many of the boys liked sitting in the very front row. We girls stayed closer to the back. Everyone had his or her customary spot. I liked the left center section toward the back. The raucous kids usually sat on the right far side. When I was invited to sit on that side once with a boy, I was frightened, not so much by having to sit next to a boy as to be on the right. Fortunately, the kids behaved that afternoon. The boy also behaved.

The Cove was a gem in our childhood La Jolla. While we children were at the Cove, our parents were probably thrilled to have the free time to do errands.

Everyone knew everyone it seemed in those days. I am talking about the 1950s. A local movie theater, a local crowd, a local scene and a small-town atmosphere. We natives miss, but cherish, our memories of our hometown movie theater.

143

20

Mount Soledad Cross Site Stirs Discord

*I*n 1913, high atop Mount Soledad in La Jolla, a cross structure was erected. Made of redwood, it could be seen from the shores below. Every Easter, citizens of La Jolla would march up the mountain for Christian services. In July 1923, not always seen as a Christian symbol, a Ku Klux Klan cross was observed burning on the mountaintop near the redwood cross. Later that year, the original cross was stolen, never to be found.

On February 29, 1930, during the interim when there was no cross on the mountain, Charles Lindbergh allowed his wife, Anne, to make her first solo glider flight. She landed safely at the foot of Mount Soledad in La Jolla Shores. Later Charles flew his glider and landed all the way beyond Torrey Pines Reserve in Del Mar. But Anne Lindbergh's flight was a landmark, as she became the first woman in the United States to receive a first-class glider license. Her glider, called a Bowlus Albatross, had been constructed by Hawley Bowlus. It was he who had previously served as superintendent of construction at Ryan Flying Company when her husband's *Spirit of St. Louis* was built.

Following these flights, the Mount Soledad Glider Club sprang up, including a women's division. Others, including students from La Jolla High School, took up the sport. Soon a request was sent to the owners of the Mount Soledad property asking for permission to construct a glider hanger. But due to a series of strict glider licensing requirements, plus the Great Depression, these plans never came to fruition.

In 1934, a citizen's committee was formed to construct a new cross on Mount Soledad. Within the year, a second cross, this time made of chicken

Climbing up Mount Soledad, looking down at La Jolla. *Courtesy of Barbara Dawson Archives.*

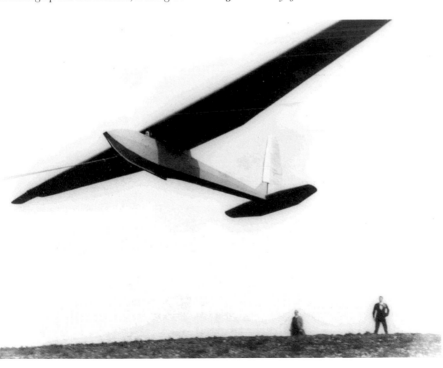

Anne Lindbergh in a Bowlus sailplane launching from Mount Soledad. Charles is the left figure. *Courtesy of Torrey Pines Gliderport Historical Society.*

wire and stucco, was built. There it remained until 1952, when high winds blew it down, destroying it in the process. Once again, the community called for construction of a new cross.

In March 1952, the Mount Soledad Memorial Association was formed. Its slogan was "Remove Not the Old Landmark." The proposed improvements for the new cross included red lights to be placed on the top of the cross as required by the Civil Aeronautics Authority. Acting president of the association Lieutenant Colonel Hugh Miller wrote:

> *Some of the highways will have to be reconstructed and those leading from Muirlands in La Jolla and from Pacific Beach will be greatly improved.... The amount of development beyond the building of the cross will depend upon the support of the people of the city and county as evidenced by their contributions to the fund. The Mt. Soledad Memorial Association Inc. (MSMA) is organizing on a county wide basis and that will give every individual and organization in the county an opportunity to contribute the amount of time, money and effort that each desires in the development of Mt. Soledad.*

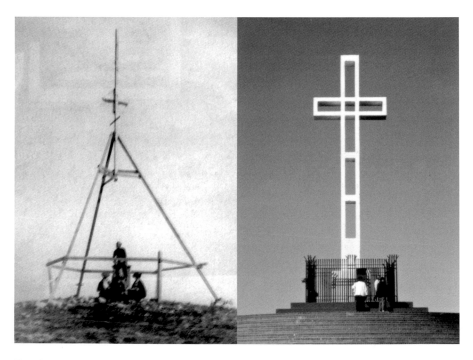

The first and most recent cross atop Mount Soledad. *Personal collection.*

On Easter Sunday, April 18, 1954, the present forty-three-foot-high, twelve-foot-wide cross, designed by architect Don Campbell in open block form to withstand the elements and vandals, was dedicated. In 1958, the cross was illuminated with floodlights; in July 1958, a seven-foot fence was stretched around the cross. The fence was a similar design to the Old Town San Diego's Serra Palm Tree fence. The cross now stands as a memorial to servicemen and women of World War I, World War II, the Korean War and all other wars that followed. According to its website:

> *The mission of the Mt. Soledad Memorial Association is to create and maintain a monument that pays homage to veterans who have honorably served our country and to educate the public on the contributions of military personnel throughout our nation's history. Shimmering black granite stories tell a tale of honor and sacrifice for the greater good upon Mt. Soledad.*

Toward the end of the twentieth century, however, the towering white cross also became a symbol of a divisive war between the City of San Diego and a La Jolla atheist over the issues of separation of church and state, free speech and freedom of religion. When a ballot measure that would have allowed the city to sell the land was defeated in the November elections, it looked as though the debate was over. The cross would be moved. But two local congressmen intervened with a proposition to keep the cross where it is.

Republican representatives Randy "Duke" Cunningham and Duncan Hunter wanted the site, which now includes more than one thousand plaques honoring veterans, named a national war memorial. They added the veterans' memorial designation as a rider to a voluminous spending bill. The bill was signed by President Bush designating the site as part of the National Park Service but maintained by the Mount Soledad Memorial Association.

"It's a shaky proposition, but if it works, we would be eternally grateful," said William J. Kellogg, president of the memorial association at the time.

Opponents felt that simply transferring the land to federal hands would not resolve the issue of separation of church and state.

"Crosses belong on churches, not in public parks," said lawyer James McElroy, who represented atheist Philip Paulson in his efforts to see the cross removed. "It doesn't make any difference if it's on federal land, state land or city land....The government should not be in the business of religion."

For years, San Diego was embroiled in a legal battle over the cross. Paulson and another atheist sued the city in 1989, and in 1991, a federal

judge ruled the cross violated the U.S. and California constitutions. He ordered it removed.

In 1998, the cross site was sold to the memorial association; however, the legality of that sale was challenged. Meanwhile, the association was making $900,000 worth of improvements to the property. What began as a simple forty-three-foot cross evolved into several walls of plaques encircling the cross. People bought plaques to honor their veteran loved ones.

For generations, San Diegans have made their way up Mount Soledad to take in the breathtaking views of the deep-blue Pacific Ocean and the surrounding lush green hills. Proposals have been made, weddings were held and ashes were scattered there. The placement of this memorial is special.

"That cross is not just a religious symbol. It's a symbol of coming of age and of remembrance," said Mark Slomka, pastor of Mount Soledad Presbyterian Church, which had been considered an alternate site for the cross. He said the church would not consider taking the cross until all other alternatives had been exhausted.

In 2006, Justice Anthony Kennedy stayed a federal judge's order that the city remove the cross or face a $5,000 fine. Later that year, the federal government acquired the property where the cross stood through eminent domain.

But as the years passed, the cross itself was becoming chipped and cracked. So, in December 2008, a local San Diego painting contractor, Jim Codde, co-owner of Bay Cal painting as well as several other companies, donated time and material to restore the cross. "Workers used a sixty-foot boom to power-wash the monument and re-weld parts of the steel interior. They used twenty-five gallons of paint on the cross and applied another four to eight gallons to the fence and green base around the cross." Mr. Codde said the project could have cost $40,000 at market prices. "That's excluding the maintenance the company has said it will handle for the next twenty years."

But the controversy over the cross continued. "This is part of a cultural war. It's a matter of which direction this country is going to go in, and we think it's worth fighting for," said Charles LiMandri, a lawyer with the Thomas More Law Center fighting to preserve the cross. Churches around San Diego were urging their congregations to pray for the cross to be saved. Rallies were held. "Many examples of religious symbols exist on public land, including the Capitol Rotunda, Gettysburg National Cemetery and Arlington National Cemetery," LiMandri said.

In 2011, the Ninth Circuit declared the structure "an unconstitutional government endorsement of religion" that, in time, may need to be torn down. The Mount Soledad Memorial Association and Obama administration appealed the decision, but the Supreme Court declined to hear it.

Finally, after twenty-five years of controversy, the future of the Mount Soledad Veterans Memorial has finally been ensured. In 2015, the U.S. Department of Defense sold the government land on which the cross stands, secure in its location. The Ninth Circuit Court of Appeals had referred to the cross as a "distinctively Christian symbol" in its 2011 ruling, thus siding with opponents who argued the cross signified "that Jesus is the Son of God and died to redeem mankind." In contrast, U.S. Supreme Court Justice Antonin Scalia suggested "the cross was a war memorial," maintaining that it was "outrageous" to conclude that all the dead veterans it honored were Christians.

Now, as of the 2015 ruling, Liberty Institute attorney Hiram Sasser states, "Today's actions will ensure that the memorial will continue to stand in honor of our veterans for decades to come."

The MSMA, which has long provided upkeep for the cross, paid $1.4 million for the memorial's half-acre of land. "We look forward to continuing to partner with the City of San Diego, our county and our military community," said Bruce Bailey, president and CEO of the MSMA's board. "It marks the first time where our membership can manage the memorial's affairs from a place of ownership and accountability for the property, which is a new and welcomed step for the association."

This iconic war memorial now honors nearly four thousand veterans and continues to add faces and names to its memorial walls. From a humble redwood cross erected in 1913 to the formation of the Mount Soledad Memorial Association in 1952, the memorial has been and will continue to be a beacon to the citizens of San Diego and part of the proud heritage of La Jolla.

21

A Brief History of La Jolla Rough Water Swim (1916–2000)

Kiwanis Club of La Jolla, December 2000

The idea came to life in the last peaceful days before World War I, when San Diego was home for the World's Fair Pan American Exposition of 1916. Pride in America, pride in Southern California and civic pride in San Diego was the tone of the World's Fair. The World's Fair Committee requested each community host a special event to showcase the city. La Jollans asked, "What better way to share our beautiful seaside community than by hosting an ocean swim?"

The World's Fair Committee sponsored the event officially known as the La Jolla Rough Water Race but also known as the Biological Pier Swim by locals. On a chilly day for summer, seven men entered the water on the north side of the recently constructed Biological Pier (Scripps Institution) and finished, approximately 1.7 miles to the south, at La Jolla Cove. Charles "Chubby" Shields was the winner in the first swim with a time of forty-eight minutes. Al Iller set his own record in 1916 as the "Official Last" in a time of one hour and fifty-four minutes. Years later, Max Miller, author of *I Cover the Water Front*, brought national fame to the swim with his famous "Official Last" races against Iller. Miller competed for more than thirty years, each of which he successfully finished last.

That first Rough Water Swim was such a great success that the organizers thought this race should become an annual summer event. But this was not yet the case. World War I intervened.

The second swim took place in 1923, with Eddie Herzog the winner in a time of forty-five minutes, three minutes faster than the winner of the first swim. In 1924, the committee failed to obtain a chairman and sponsor but rallied in 1925 under the guidance of Al Iller and the American Legion with a race and a star. Olympic swimmer Florence Chambers entered and bested men and women alike.

The Rough Water Swim became a truly annual event in 1931, held every year thereafter except 1935, when sponsorship supported the San Diego Exposition that year. In 1947, Gregory Peck, who was in La Jolla preparing for the July 8 opening of the Summer Playhouse, presented the trophy to Beverly Pearson. In 1948, concerns of polio forced cancellation. The last cancellation was in 1959 when unusual shark sightings were reported. Unofficially, one of the swim organizers, local businessman Douglas McKeller, in a display of confidence, entered the water at the appointed time and swam the course. No sharks were sighted.

Over the swim's eighty-four-year history, the course has changed several times. In 1941, after complaints that the course was unnecessarily grueling, officials made the first course change, starting at the recently completed La Jolla Beach & Tennis Club and finishing, as before, at the Cove (two-thirds of a mile). In 1946, the original pier to Cove course was tried one last time after which, in 1947, the current one-mile triangular course originated. In 1952, a junior course (150 yards) was added to give younger swimmers a chance to compete. In 1982, the junior course was lengthened to its present distance of 250 yards. Most recently, in 1993, the challenging Gatorman® Three-Mile Championship was added for elite swimmers. Coincidentally, the Gatorman's course is similar to the "grueling" original 1916 route, with one exception. Today's elite Gatorman men and women now swim the course twice, from the Cove to the pier *and* back.

Today's triangular courses and the natural arena-like characteristics of the La Jolla Cove offer spectators an exceptional view of the entire Rough Water Swim. Spectators of the early swims, for the most part, had to make a choice of watching either the start or the finish. This was indeed a difficult choice, as an unaccredited journalist wrote, "One of the greatest thrills in water sports is to watch the hundreds of contestants strike the Pacific at the start of the La Jolla Rough Water Swim." The finish, of course, has obvious appeal.

While the course has undergone a few changes, there has been a remarkable expansion of the number of swimmers. Seven men entered the first swim in 1916. The 1925 event hosted 8 men and 11 women. In 1938, 82 swimmers participated. By 1950, entries had increased to 105, and in 1970,

Mad dash start of the La Jolla Rough Water Swim. *Courtesy of the La Jolla Kiwanis Club.*

entries broke through the 300 level. The 1,000-swimmer mark was shattered in 1984, followed in 1996 by the first 2,000-swimmer event. The swim currently averages more than 2,000 competitors, which has earned this annual summer classic the national ranking of No. 1 (America's Premier Rough Water Swim) and one of the reasons the event has been affectionately nicknamed the "Big Wet One." The swim, however, will unlikely grow much larger in the future. In 1996, a limit was placed on the number of competitors to preserve the high standards established by the early Rough Water Swim Committees.

The World's Fair Committee sponsored the first swim, followed by the American Legion, Mrs. Hopkins (who developed the Casa de Mañana), La Jolla Chamber of Commerce, La Jolla Beach & Tennis Club, AAU and the La Jolla Town Council.

Over the past eighty-four years, the sponsorship has changed, the course has been altered slightly and the number of participants has increased. However, its 100th anniversary, scheduled for September 2016, was postponed.

"Due to the poor ocean water quality and high bacteria levels currently present at La Jolla Cove, we defer the Annual La Jolla Rough Water Swim event until the Cove's ocean water and beach conditions improve. The safety of our swimmers has always been our primary concern," wrote Bill Perry.

"The Committee feels that to subject our entrants to the Cove's poor ocean water quality this year would be irresponsible and contrary to the

high standards of this 100-year-old event. We have always strived to provide a first class aquatic event for all members of the family and we don't feel that would be possible this year considering the current conditions at La Jolla Cove."

"Additionally, sea lions have taken up residence on the beach and rock configurations surrounding La Jolla Cove in such numbers that swimmers have begun entering the water from other beaches, to avoid the fecal pollution and unpleasant smell, as well as the aggressive behavior of the animals during their recent mating season," reports Anne Cleveland, a Cove regular.

A little aside: According to the La Jolla Historical Society in its 1987 book, *Inside La Jolla*, "Bathing suit attire was not acceptable to the Town Council except in the immediate vicinity of the beach. A garment was required to be worn over the bathing suit on village streets." Obviously, this is no longer a requirement!

22
Enchanted Forest

Torrey Pines State Reserve
By Terry Rodgers,
for the San Diego Union-Tribune *(1999)*

New Age crystals or divining rods aren't necessary to feel the power of this place where North America's rarest pine tree has made its last stand.

More often than not, sightseers who venture into Torrey Pines State Reserve are enchanted by this prickly landscape where blossoms sprout and shrivel in sync with the brief life cycles of insects. [Over] one hundred years ago [1899], at the height of the Industrial Revolution, that same grandeur captivated San Diego's pioneering leaders.

Impassioned by their affection for the site and its dramatic, twisted trees, they set aside a few hundred acres to be spared from development.

What began as a municipal park evolved into a sanctuary where a unique piece of California's natural heritage is preserved. What kind of a park is this where no gardeners toil to plant, prune and fertilize?

Visitors aren't allowed to picnic, walk their dogs or smoke cigarettes on the hiking trails. And don't even dare to fly a kite. That, too, is prohibited.

The numerous restrictions, which are even more stringent than those at the state's remote wilderness areas, are intended to keep human intrusions to a minimum.

As a result, the reserve offers a feast of native species for amateur naturalists, bird watchers and wildflower enthusiasts.

"The trees and the ocean, there's something stark and unique about it which you don't find anywhere else in Southern California," said Del Mar author and naturalist Barbara Moore. "There's something soothing about it. It makes me feel more connected."

Ken Baer, 37, a banker and president of the 120-member Torrey Pines Docent Society, felt that same connection when he first visited the reserve as an 11-year-old. "You go for a walk on one of the trails and it feels like you're far away from civilization," he said. "There's a peace and tranquility there that, when the jets and choppers (from nearby Miramar Marine Corps Air Station) aren't flying over, you can't find anywhere else." Baer, a running enthusiast, is among the many joggers who gravitate to the sage-scented reserve to avoid automobile exhaust.

Landscape photographer Bill Evarts has discovered the secret pleasure of exploring Torrey Pines State Reserve whenever fog smothers the place like a layer of meringue. "Everybody goes home, but that's when it's

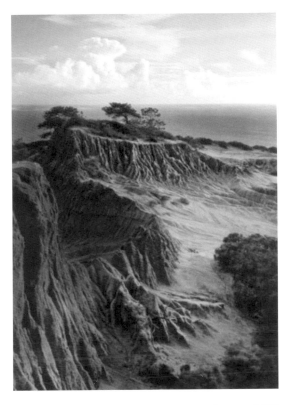

Broken Hill, Torrey Pines State Reserve. *Courtesy of Bill Evarts Photography.*

the most interesting and magical," said Evarts, 52, who spent seven years writing and photographing for a book about the reserve. "The ghostly silhouettes of the trees reinforce their mystery, how they got there. It's real quiet, except for the dripping of the fog off the pine needles. You can hear the ocean, but you can't see it. Your imagination can really take off."

The reserve is a collage of habitats, coastal sage, chaparral and wetland where coyotes and the occasional mountain lion still chase down prey ranging from pocket mice to mule deer.

It's also an outdoor museum, a 2,000 acre oasis of native landscape that, despite being just 16 miles from downtown San Diego, hasn't changed much in a century.

"There's quite a dynamic ecosystem going on here," said chief ranger Robert Wohl. Much to his dismay, the evidence of that often ends up as road kill along Torrey Pines Road, a five-lane road built in 1930 that bisects the reserve. In the past six months alone, rangers have removed the carcasses of three deer that were killed trying to cross the 50-mph highway.

Rampant urbanization east of the reserve threatens to throw the ecological balance off kilter by cutting off wildlife corridors used by larger mammals to travel between habitats.

The reserve is the flip side of a zoo. Here, it's the humans who are confined. The critters are free to roam wherever their instincts take them. "Ninety percent of this land is closed off to the public," Wohl noted. "But, because the state beach is almost five miles long, it gives the illusion that the whole place is open."

Torrey pine tree etching from Torrey Pines State Reserve brochure. *Courtesy of the Torrey Pines Docent Society.*

The reserve is composed of four segments: a narrow, hard-to-reach state beach; the 1,000-acre main reserve off Coast Highway 101; a 225-acre reserve "annex" hidden among homes in southern Del Mar; and the 385-acre Los Penasquitos Lagoon.

The overarching management policy is to let it be. When a tree falls, it isn't necessarily cleared away. When wasps burrow into the ground next to a hiking trail, they have the right of way.

"We're here to preserve the natural California landscape," said Wohl. "The idea is not to impose man's willpower on nature."

Despite the restrictions, 1.5 million people visited the reserve and its 12 miles of hiking trails last year. For many, the main attraction is the groves of Torrey pine, which comprise the only coniferous coastal woodland in Southern California.

The endangered pines are living sculptures, trees that have contorted themselves into Tai Chi-like poses as a result of punishing winds, feeble soil and irregular rainfall.

The isolated groves clinging to the edge of the Pacific Ocean were so distinctive that Spanish mariners in the 1500s named it "Punta de los Arboles" (Wooded Point) and used it as a navigational landmark.

Today, fewer than 10,000 of the pines remain. The majority are perched atop the 350-foot-tall sandstone bluffs between Del Mar and La Jolla. The remaining groves are on Santa Rosa Island 175 miles to the northwest.

How these vulnerable trees managed to persist is not fully understood.

Genetic tests found that Torrey pines are nearly clones of each other, like the stalks in a corn field. "As far as we can tell, there's no genetic diversity (among the trees)," said Mike Wells, a state resource ecologist. "They're all identical twins." Thus, the Torrey pine is an orphan species for which evolution has stopped. Natural selection, the process by which the strong outlive the weak, cannot occur.

First identified as a distinct species by botanist C.C. Parry in 1850, the same year as statehood, the Torrey pine became known as California's birthday tree.

After wood cutters reduced the grove to about 200, the Torrey pine was saved from extinction by forward-thinking civic leaders, led by San Diego businessman George Marston, who persuaded the San Diego City Council to protect the grove. On Aug. 10, 1899, the council voted to set aside 369 acres of Torrey pines as a park but allocated no money for enforcement or management.

When developers threatened to isolate the forest, Ellen Browning Scripps bought out the land speculators so the reserve could be expanded. In her will, she donated the land to the city.

The [La Jolla] philanthropist also hired Guy Fleming, a naturalist and visionary who, in addition to becoming the reserve's first caretaker, helped create California's State Park system.

Over the century since the reserve was established, it has withstood numerous threats. Supporters rallied public opinion to defeat an oceanfront road proposed in the 1920s that would have forever scarred the delicate cliffs.

Guy L. Fleming. *Copyright La Jolla Historical Society.*

During the 1960s and '70s, the reserve was often abused by revelers who used it as a site to party and unleash their inhibitions. "The place was a spider web of trails; it was out of control," recalled Wohl, the chief enforcement officer at the reserve for 20 years. Fat Man's Misery, a narrow but spectacular canyon painted by mineral secretions and sculpted by erosion, became so popular it was often congested with a human chain of hikers. Fed up with the litter and vandalism from those who carved their names on the canyon wall, the state in 1974 closed Fat Man's Misery. It has since been renamed Canyon of the Swifts.

Nature wasn't kind to the reserve, either. A drought coupled with a bark beetle infestation wiped out 700 trees between 1988 and 1992.

Perhaps no one knows the reserve's subtle charms more intimately than Greg Hackett, a park ranger who has been the overnight caretaker for six years. Hackett occupies the 1927 home built for Fleming, the patron saint of the reserve. While he is occasionally awakened in the middle of the night by trespassers or drug runners unloading illicit cargo on the beach; Hackett said he has found true solitude in the place where "all my neighbors are pine trees." Like the chimes of a church bell, a great horned owl serenades him each evening. Sitting in his rocking chair next to a pot-bellied wood stove, he can sense the spirit of the caretakers who came before him.

"The lion's share of park visitors consider this place the same as I do, as a sanctuary," he said. "We're not high-tech here. We have no laser light show.

"The way it used to be is the way it still is."

23

Soaring Over La Jolla

The Importance of the Torrey Pines Gliderport
By Gary B. Fogel

*T*he Torrey Pines Gliderport in La Jolla has been a unique historic resource for motorless flight since 1930. The geography of a three-hundred-foot cliff facing a prevailing sea breeze routinely creates the perfect conditions for ridge soaring. Pilots in motorless aircraft can soar back and forth in an inverted "waterfall" of rising air so long as the wind continues to blow. San Diego's idyllic climate generates favorable soaring conditions for ridge soaring on most days, and this combination of geography and weather is unparalleled in the United States. The birds knew about this long before people realized it was possible to emulate them in heavier-than-air flying machines. It is no wonder then that America's first glider pilot, John J. Montgomery, experimented in the San Diego area. His gliders and theories developed between 1883 and 1886 at Otay near Chula Vista helped pave the way for the science of aerodynamics. For a short time, La Jollans Frazer Curtis and Nathan Rannels experimented with an early hang glider in 1910 from the slopes of Mount Soledad near Pepita Way. These short hops were the first flights made in the town of La Jolla.

Following the successful crossing of the Atlantic by Charles Lindbergh in the *Spirit of St. Louis* in 1927, aviation experienced its golden age. Kids of all ages wanted to know what it was like to experience flight, to be the same as "Lucky Lindy." During the Great Depression, this was especially difficult due to costs. Gliders represented an inexpensive means to take to the sky. The flights were short, typically only downhill, but gave just enough of a thrill for some of these students to begin their careers in aviation.

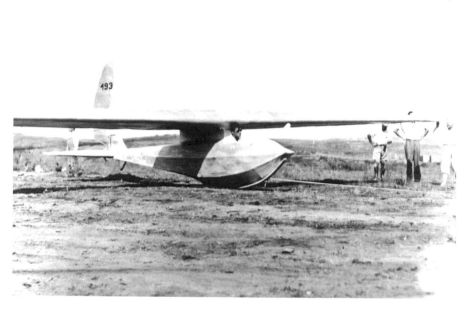

Bowlus sailplane of type later used by the Lindberghs. *Courtesy of San Diego Air and Space Museum.*

The superintendent of construction on the *Spirit of St. Louis* for Ryan Aircraft in San Diego was William Hawley Bowlus. Hired by Claude Ryan for his excellence in design and management, Bowlus had built a series of fifteen gliders prior to 1927. Construction on his sixteenth glider started soon after Lindbergh's success with test flights at various locations in San Diego, including Point Loma. This was America's first true "sailplane," a machine built light enough, strong enough and sleek enough not to just glide downhill, but specifically designed to extract energy from the atmosphere and soar like a bird. This design was so successful that he soon established U.S. endurance records for soaring, extending duration from just tens of minutes to over nine hours. These accomplishments made national headlines, as people wondered how it could be possible for an aircraft without a motor to stay up for more than just seconds. Bowlus established a sailplane company and glider school at Lindbergh Field and continued to refine his designs.

In 1930, Charles Lindbergh returned to San Diego with his wife, Anne, specifically to take instruction from Bowlus in this burgeoning sport of

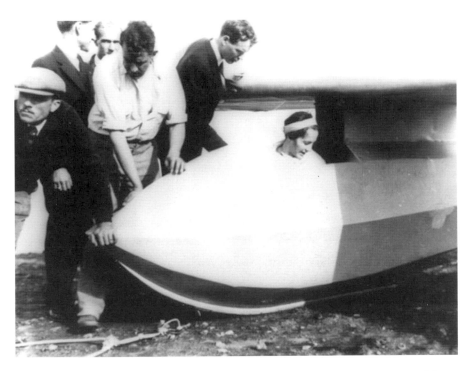

Anne Lindbergh learning to glide from Mount Soledad with Charles, 1930. *Courtesy of San Diego Air and Space Museum.*

soaring. Anne became captivated by the sport as well, and her launch from the top of Mount Soledad in January 1930 was not only the first glider flight from the top of the mountain but qualified her for the first "first-class" glider license held by a woman in the United States. Mount Soledad was soon recognized as a superior location for soaring, as launches could be made in many directions. Not to be outdone, on February 24, 1930, Charles Lindbergh was launched in a Bowlus sailplane from the top of Mount Soledad and flew to the north, toward the cliffs at Torrey Pines. There he reasoned he should find lift, just like the soaring birds. He did and continued soaring to a landing on the beach near Del Mar. Not only did the flight establish a western regional soaring distance record, but it also represented the first use of the lift at Torrey Pines by something other than a bird.

These and other events of early 1930 led to some remarkable transformations in the local area, both societal and educational. The Anne Lindbergh Gliders Club (one of America's first all-women glider clubs) formed, showing that gliding and soaring was not just a man's sport. Woodshop instructors at local high schools taught glider construction

instead of tables or chairs. Students from La Jolla High and San Diego High began flying their gliders from hillsides throughout the San Diego area on a regular basis, as glider clubs formed in most towns in Southern California. Spurred by Charles Lindbergh's glider flight to Del Mar, several youngsters flew their gliders from the beach at the base of Torrey Pines Grade, using cars to tow the gliders into the air with a rope. Once aloft, good pilots could soar for long periods on the updrafts and then land on the beach for the next student to take a turn. One of these students was John Robinson, a San Diego High School student who later had a stellar career as America's first three-time national soaring champion and the world's first recipient of the Diamond "C" badge, the highest achievement award in soaring.

However, the first pilot brave enough to launch and land a glider from the tops of the cliffs at Torrey Pines was Woodbridge "Woody" Parker Brown. Woody came to La Jolla from New York, where he had limited prior experience with gliders. Arriving in La Jolla in 1935 with his wife, Betty, he became very interested in surfing and was one of the first to surf Windansea and Black's Beach. Rather quickly, Woody imparted his knowledge of aviation onto surfing. The longboards of the time were heavy solid planks. Woody reasoned that it would be possible to build hollow surfboards with internal ribs, similar to airplane wings. He also added a skeg as a "fin" to keep the surfboard going straight. These advances helped surfing, but it wasn't long before Woody learned of the boys flying gliders on the beach at Torrey Pines and began assisting them as well. He was fascinated by any sport that worked with nature rather than against it. Woody helped identify a suitable launching location on top of the cliffs. The first location he tried nearly led to disaster.

One day after a big rain, the ground was wet and slippery. As my wife was towing me off with the car, the wheels slipped in the mud and did not give me full power in the takeoff. When I failed to get off the ground, coming near the edge, I put the wing tip in the ground, gave full rudder and ground looped to a stop with my tail sticking out over the edge of the cliff. So finally we found a better place at the best place on the cliffs. [Woody's description above is of the UC San Diego Ecological Preserve, the Knoll, the only remaining natural undeveloped cliff top area. It is located about three-fourths of a mile south of the present-day Torrey Pines Gliderport and a quarter mile north of Scripps Institution of Oceanography.

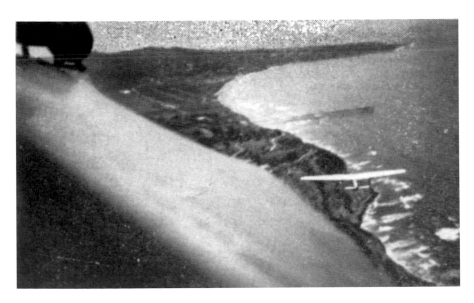

Peering out of the cockpit of Woody's *Swift* toward La Jolla and the Scripps Pier in 1937. John Robinson's *Robin* sailplane floats below. *Courtesy of* Soaring *magazine*.

John Robinson (*left*) and Woody Brown in front of the *Swift* sailplane circa 1937 at the Torrey Pines Gliderport in San Diego, California. *Courtesy of* Soaring *magazine*.

Woody built his own glider, the *Swift*, and together with buddies John Robinson and Alan "Dick" Essery formed a trio that would be a force for both scientific and competitive soaring in the region during the late 1930s and early 1940s. Together, they also introduced the "dead-man pulley tow takeoff" system to use a pulley to rapidly accelerate gliders off Torrey via car tow. This was later expanded to a double pulley system. They investigated ways to increase aircraft efficiency, to challenge and inspire one another, to learn from and use their environment. This attraction of "working with Nature rather than against Nature" became a mantra of glider pilots at Torrey Pines to the present and also resonated well with La Jollans.

In 1939, Woody established a new American goal distance record of 280 miles by flying from Wichita Falls, Texas, to Wichita, Kansas, in his *Thunder Bird* sailplane. This flight was so miraculous for the time that he was featured in *Ripley's Believe It or Not!*, and he even received a congratulatory telegram from President Hoover. Tragically, not long after returning to La Jolla, Woody's wife, Betty, passed away during childbirth. Distraught and in a state of disbelief, Woody drifted between soaring and surfing. Relatives stepped in to raise his children, as Woody moved to Hawaii to begin life anew. Surfing continued as his passion. Woody and a small group of surfers on Oahu were the first in modern history to brave the huge sets on the north shore of Oahu. These very early forays are now legendary in surfing history. One day in December 1943, Woody and a surfing buddy Dickie Cross attempted to surf at Sunset Beach. They started the day riding twenty-foot waves. However, rather quickly the waves grew to forty feet or more. They were quickly trapped at sea, attempting to simply survive the huge waves. With the sun setting, they decided to paddle to nearby Waimea Bay, thinking it might be easier to come ashore there before nightfall. While attempting to do so, Cross was overcome by the waves (which both Cross and Woody had estimated at the time to be roughly sixty feet high, with whitewater as high as twenty feet). Dickie Cross and his surfboard were never seen again. Woody was fortunate to wash up on shore alive, owing in large part to his skill as a free diver, swimming down, well below the pounding waves. This legendary "big wave" story is known internationally in surfing. Many surfers, including Woody, avoided waves on the north shore of Oahu for the next fifteen years. Sometimes when you attempt to work with nature, nature reminds you who is in charge.

In 1947, Woody designed and built the first modern catamaran, a design inspired by the vessels of the native Polynesians. This catamaran, aptly named the *Manu Kai* (Sea Bird), was credited at the time as being the fastest sailboat in the world. Woody's skill at woodworking and design was self-evident. His skill at

piloting a sailboat was equal if not more impressive than his skill as a glider pilot. And with the *Manu Kai*, he started a business of selling rides to tourists along the beach at Waikiki, the first to do so. One passenger, Hobie Alter, became a regular and befriended Woody. Hobie decided to build his own line of catamarans (the famous *Hobie Cat*) and take out a patent on the design. Woody had no interest in patents or selling copies of the *Manu Kai*, and Hobie and Woody remained good friends. (In a very circular way, Hobie Alter also went on to design a very popular radio-controlled model sailplane in the 1970s, known as the *Hobie Hawk*, which became extremely popular with enthusiasts at the Torrey Pines Gliderport. Few modelers realize the connection of the *Hobie Hawk* back to Woody Brown.)

Hawley Bowlus continued his passion for soaring after his time in San Diego, developing several key sailplanes that were used by pilots to establish national and world records. Some of these designs were offered as kits during the 1940s, sailplanes that could be built in a large garage at low expense and yet offer reasonable performance. So popular were these kits that it was common on the weekends at Torrey Pines in the late 1930s and early 1940s for the majority of the sailplanes to be Bowlus designs. However, Bowlus didn't stop there. Prior to World War II, Bowlus designed what is considered to be the first recreational vehicle, the *Bowlus Road Chief.* This aluminum travel trailer had all the comforts of home in a very aerodynamic structure that looked more like a large aircraft fuselage. During World War II, Bowlus helped design training gliders used to instruct the pilots that would fly larger troop transport gliders behind enemy lines during invasions.

Woody Brown and Hawley Bowlus are just two of many examples of pilots who have used the Torrey Pines Gliderport to improve their skills, as a testing ground for new designs and in new ways to extract energy and enjoyment from nature. Many others, including Dr. Paul MacCready (first to design a human-powered aircraft to cross the English Channel), Brigadier General Bob Cardenas (pilot of the B-29 that launched Chuck Yeager for his flight to break the sound barrier), Helen Dick (first woman in the world to be awarded the Diamond C badge), Bill Ivans (a La Jollan who established a world record altitude gain for sailplanes of 42,089 feet on December 30, 1950, over the Sierra Nevada Mountains) and others all have their own stories that trace back to a common source: the unique and exceptional resource that is represented by the Torrey Pines Gliderport.

During World War II, the gliderport and its surrounding area was transformed into U.S. Army Camp Callan. Ironically, this base featured antiaircraft training programs. After the war, the glider pilots returned to Torrey Pines and have been soaring there ever since. Radio-controlled sailplanes

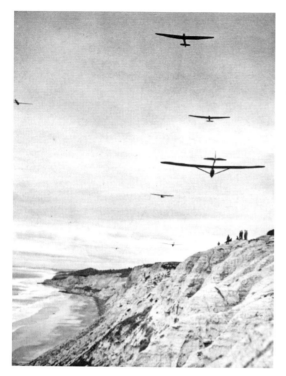

An active day during a soaring contest, 1950s. The top glider is a TG-2 World War II training glider still flying today. Torrey Pines Reserve is in the background. *Courtesy of Gary Fogel.*

were added in the 1950s as the amateur radio equipment became small and reliable. Hang gliders joined the scene in the early 1970s as the sport of hang gliding experienced a renaissance at Torrey Pines. Four world records for hang glider endurance were established at the site in the 1970s. As recently as the late 1980s, paragliders also started flying at Torrey Pines using controllable parachute airfoils to soar on the updrafts. Torrey Pines is now not only unique for its geography and reliable wind but also for the mark this location has left on four disciplines of motorless flight. The gliderport has been recognized as a National Soaring Landmark of the National Soaring Museum, is a historic site of the City of San Diego and is listed in the California and National Registers of Historic Places. It has also been recognized as Model Aviation Landmark No. 1 by the Academy of Model Aeronautics for its contributions to the history of aeromodelling.

Soaring is unique in that it allows the participant to become one with the aerial environment—to experience life as a bird. Armed with a healthy respect for nature and an interest in pushing limits, pilots can not only extend boundaries in the air but also extend this knowledge to other disciplines, such as surfing and sailing, transportation or simply life in general. While the historic importance of the Torrey Pines Gliderport is grounded in aviation, the site captures the California spirit of innovation and trying new things in new ways while doing more with less. Few places have had such lasting effect, and it is this pioneering spirit that continues to make the Torrey Pines Gliderport one of La Jolla's jewels.

24
Final Comment

The controversy over La Jolla seeking independence from San Diego has sparked much criticism. This is America, after all. We are supposed to be a classless society, but from the letters and responses we have received, it appears the class system is alive and well in the hearts of many San Diegans. A sad fact. We regret the designation of La Jollans as "affluent objectors," "demanding constancy," elitists, etc.

La Jolla has a history, a special and unique history. We have been blessed with people like Ellen Browning Scripps, who reminded us back in 1899 that "[i]t lies with us residents and owners of La Jolla to make 'our jewel' what we will, only keeping it always in harmony with its glorious natural setting." The setting, the beauty of sand, surf, sunsets, the caves, Mount Soledad and the Torrey Pine Reserve inspire writers, painters, poets, performers and scientists. Once again, our benefactor and mentor, Miss Scripps, wrote, "It will matter little then if our homes are stately or unpretentious cottages. For here the poet will find his inspiration, the teacher his lessons. Here the artist shall realize his dream, the weary and suffering shall find rest and solace, and every soul shall be satisfied; for it shall awaken the likeness of its creator."

This speech reflects the philosophy behind our wish to secede. We who have grown up in La Jolla, we who have lived many years in this lovely place, wish to preserve just that, a place of inspiration and solace. We do not want to go back to the past, but we do believe that we can learn from the past.

It is not to close the doors to the people of San Diego that we wish to have control over our own destiny. It is to preserve a sense of place, the

integral beauty of this little town with a funny name. Del Mar has preserved a unique charm. Coronado has fought to do the same. That is all we wish to do. La Jolla is a lovely place to visit. We wish to keep it that way. There are no gates to close others out.

La Jolla has been a magical spot, a place of inspiration for not only artists but also scientists, including twenty-seven Nobel Laureates. Please understand, it is not about money, prestige or class; it is about preserving the spirit of the place as only its own citizens can do. Keep La Jolla as a place to relax, to retreat, to inspire. Cliff Robertson called La Jolla his anchor, "an anchor that holds my life steady in this stormy life while all about is turbulence." Please help us preserve that anchor before it becomes another Miami Beach.

Bibliography

Eastman, Sarita. *A Trail of Light: The Very Full Life of Dr. Anita Figueredo.* Bloomington, IN: Worldclay, 2009.

Hines, Thomas S. *Irving Gill and the Architecture of Reform: A Study in Modernist Architectural Culture.* New York: Monacelli Press, 2000.

La Jolla Historical Society. *Inside La Jolla, 1887–1987.* San Diego, CA: La Jolla Historical Society, 1986.

Olten, Carol, Heather Kuth and the La Jolla Historical Society. *La Jolla.* Charleston, SC: Arcadia Publishing, 2008.

Schaelchlin, Patricia A. *La Jolla: The Story of a Community.* La Jolla, CA: Friends of the La Jolla Library, 1988.

———. *The Newspaper Barons: A Biography of the Scripps Family.* San Diego, CA: San Diego Historical Society in association with Kales Press, 2003.

Waddy, Lawrence. *A Parish by the Sea: A History of St. James by-the-Sea Episcopal Church.* La Jolla, CA: Saint James Bookshelf, 1988.

Index

About the Author

*P*atricia Daly-Lipe grew up on both sides of the country: La Jolla, California, and Washington, D.C., the home of several generations of her mother's family. After graduating from The Bishop's School in La Jolla, she began her studies at Vassar College. Her mother returned to Washington, D.C. Just prior to her sophomore year, her mother died. Patricia was only eighteen. She returned to Vassar College with a year at the Catholic University of Louvain, Belgium, where she earned a *Bachelier en Philosophie Thomiste*. Then, after living for

three years in Louvain, Paris and Rome, she returned to Washington, D.C., and wrote for the *Evening Star* newspaper. Later, with a degree in philosophy from Vassar College, she earned a master's degree followed by a doctorate in creative arts and communication.

Later, as a single parent of three children, she raised, raced and showed Thoroughbred horses. Now she rescues them; another two generations of her family are still showing horses.

Over the years, Daly-Lipe has taught English and writing, written for magazines, penned a newspaper column and shown and sold many of her paintings.

She was also president of the La Jolla branch and, later, the D.C. branch of the National League of American Pen Women.

Author of nine books, Daly-Lipe was the 2002 winner of San Diego Book Awards Association, recipient of the 2004 Woman of Achievement Award NLAPW, Best Books Award Finalist and first runner-up trophy winner of the JADA Award Winning Novel Contest 2006. At the 2007 Spring Conference of Capital District 36 Toastmasters, she was given recognition for her presentation, "The Power of Words." In 2010, Cambridge Who's Who recognized her as "an expert resource in the field of Creative Writing" and a VIP. The Daughters of the American Revolution presented her with a Certificate of Award in 2012 (March) for the presentation of *A World of Women*. In 2013, *A Cruel Calm: Paris Between the Wars* won first prize in historical fiction from the Royal Dragonfly Book Awards.

Married to her second husband but first boyfriend from La Jolla, Dr. Steele Lipe, Patricia and Steele live in Virginia with their rescued Thoroughbred horses, dogs and cats. However, they also have a home in La Jolla and go back often. Patricia has six grandchildren and, in 2016, became a great-grandmother.

Please visit www.literarylady.com.